*A Tour of*
# Australian Rock Art

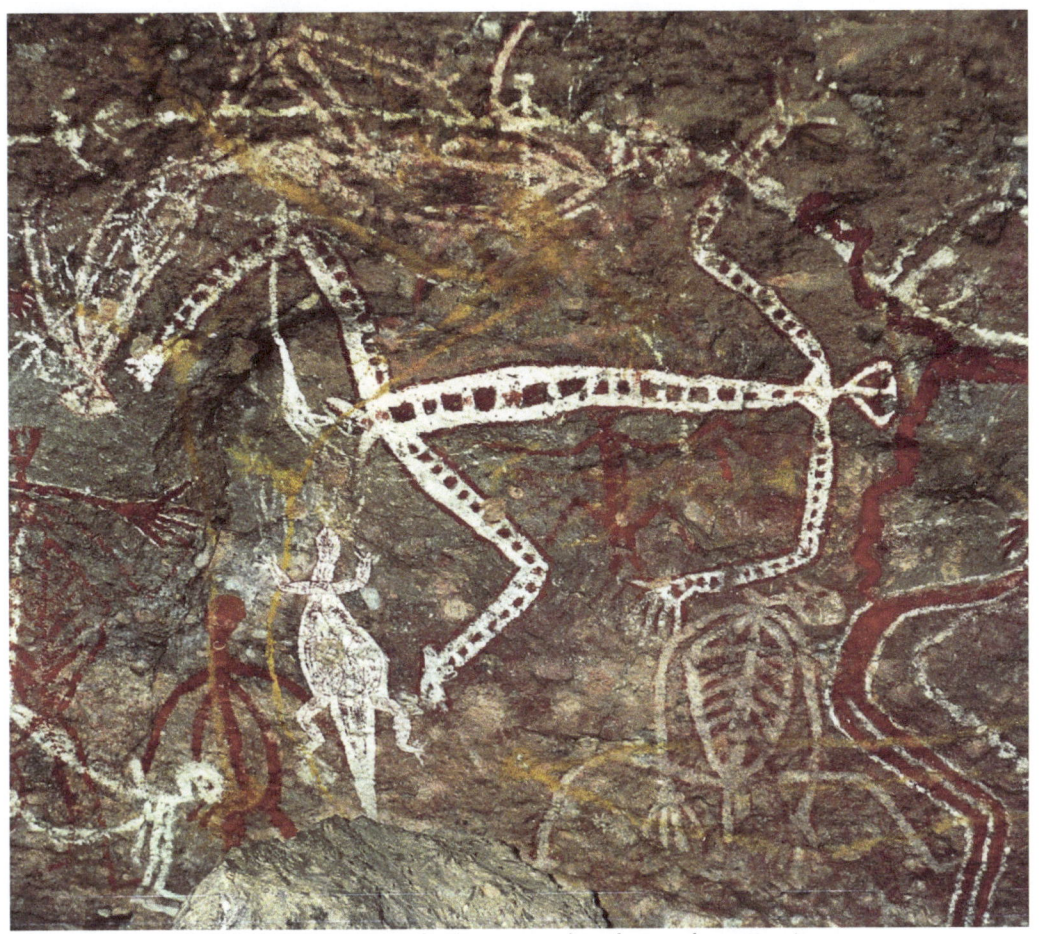
Crooked Woman, Kakadu National Park, Northern Territory

## Leon Yost

Copyright © 2017 Leon Yost
ISBN: 978-1548901226

# Contents

**Jowalbinna Bush Camp, Cape York Peninsula**

| | |
|---|---|
| *Emerging Man* | 6 |
| *Spirit Woman* | 8 |
| *Red Lady* | 10 |
| *Levitating People* | 12 |
| *Guardian and Garfish* | 14 |
| *Giant Wallaroos* | 16 |
| *Swirling Figures* | 18 |
| *Hovering Quinkin* | 20 |
| *Red Matriarch* | 22 |
| *Flying Man, Flying Woman* | 24 |

**The Wardaman Tribe, Northern Territory**

| | |
|---|---|
| *West to Willeroo* | 26 |
| *Lightning Brothers* | 28 |
| *Young Lightnings* | 30 |
| *The Life Cycle* | 32 |
| *Guardian Matriarch* | 34 |
| *Maravanna Lady* | 36 |
| *Fertility Place* | 38 |
| *Old Devil Lady* | 40 |
| *Red Kangaroos* | 42 |
| *Red Barracuda* | 44 |
| *Rainbow Serpent* | 46 |

**Victoria River District, Northern Territory**

| | |
|---|---|
| *Serpent Person* | 48 |
| *Decorated Turtle* | 50 |

**Kakadu National Park, Northern Territory**

| | |
|---|---|
| *Road to Arnhem Land* | 52 |
| *The Thin Fisherman* | 54 |
| *Many Fish* | 56 |
| *Tall People* | 58 |
| *Crooked Woman* | 60 |
| *Procession* | 62 |
| *The Woman Eater* | 64 |

**Bibliography**   66

**Cover:** *Golden Fish, Kakadu National Park, Northern Territory*

## Dedication

This book is dedicated to **the Wardaman tribe** and elder, **Yidumduma**, aka, **Bill Harney**, who hosted our small group at the Willeroo bush camp and guided us to spectacular rock art sites on their ancestral land. Yidumduma explained the meaning of the art, reciting the stories and answering endless questions. Sincere thanks for allowing me to publish these photographs.

## Acknowledgments

Profound thanks to the generous guides and advisors without whom this book would not have been possible–and to **Erma Martin Yost** for her careful notes in the outback and manuscript comments back home.

Special thanks to these experts, without whom this book would not have been possible:
**Robert Bednarik** of the Australian Rock Art Research Association and the International Federation of Rock Art Organizations for his invaluable advice and contacts.
**George Chaloupka** of the Northern Territory Museum of Arts and Sciences for sharing his expertise on Kakadu National Park and his comprehensive book on Arnhem Land.

**Mary Haginikitas,** our tireless guide for four days at Jowalbinna. She knows that complicated land like the back of her hand.
**Ken Hedges** of the Museum of Man, San Diego, for site tips from his visit to the outback several years before.
**Janice Tanaka** and **Michael Nock**, filmmakers from Los Angeles, who shared their videos of Yidumduma telling his tribe's stories at Willeroo.
**Percy Trezise**, author, artist, explorer and anthropologist, his sons **Stephen** and **Matthew**, his sister, **Olive** and her husband **Neville** for warmly hosting us at the Jowalbinna Bush Camp. Sincere thanks for allowing me to publish these photographs.

## Introduction

Just after sunrise in early July 1993, Erma Martin Yost and I caught the mail plane to Jowalbinna Bush Camp, beginning our 2.5-week tour of Australian rock art. July is winter in the southern hemisphere, but because it's near the equator, northern Australia's days are similar in length year round. July is in the dry season, making backcountry exploration possible–unlike during the river-flooding monsoon beginning in October. We flew from Sydney to Cairns to Jowalbinna to Darwin and back, camping in a little pup tent, driving a worn out Land Rover and hiking the outback with experienced guides, including Yidumduma, the last initiated male elder of the Wardaman tribe.

I had spent a year researching sites through the American Rock Art Research Association, the Australian Rock Art Research Association and the International Federation of Rock Art Organizations. Erma was already in Sydney for the spring term, teaching art at the Abbotsleigh girls' school where she was on an exchange with The Spence School in New York City.

This book is a photo-tour of three regions of rock art: Cape York Peninsula in the northeast, the Wardaman tribal land in northwestern Northern Territory and Kakadu National Park in northeastern Northern Territory. The Aboriginal culture still survives in some of these regions–well separated from the coastal cities where most of the *new* populations (mostly European and Asian) reside. Aboriginals have no written language in the western sense. Their oral stories are their history, often illustrated in the rock art. Richly detailed, the stories are often set in the creation time, or *dreamtime*, when trees could walk and animals could talk.

Unless specific Aboriginal names were available, I've invented those in this book for reference and context.

## *Emerging Man*
*Cape York Peninsula*

**In early July 1993,** Erma Martin Yost and I boarded the mail plane in Cairns, Australia, heading for the Jowalbinna Bush Camp in the far northeastern corner of the continent–up near the equator. An hour later, we touched down on a grassy field next to a waiting Land Rover and soon were driving through gum tree groves toward camp. The sound of our twin-engine Cessna faded in the distance as it turned toward the next stop on its twice-a-week rounds.

July is winter in Cape York Peninsula, but the climate is tropical, with just two seasons–the wet and the dry. It's warm year-round but July is in the dry season, and the only time possible to ford the creeks–which swell through the lowlands in the monsoon.

Our rock art guide, Mary Haginikitas, met us at noon and with packs on our backs, we headed out through thigh-high Mitchell grass toward sandstone bluffs in the distance. This is land where Aboriginal peoples thrived before the Europeans arrived.

The *Emerging Man* was the first pictograph we saw that day–a six-fingered man in red ochre, emerging from a crevice in the warm-toned rocks. Mother earth giving birth? We'll never know for sure because the Aboriginals from this area are gone, and the stories are gone with them. ▷

*Landing field at Jowalbinna, Cape York Peninsula.*

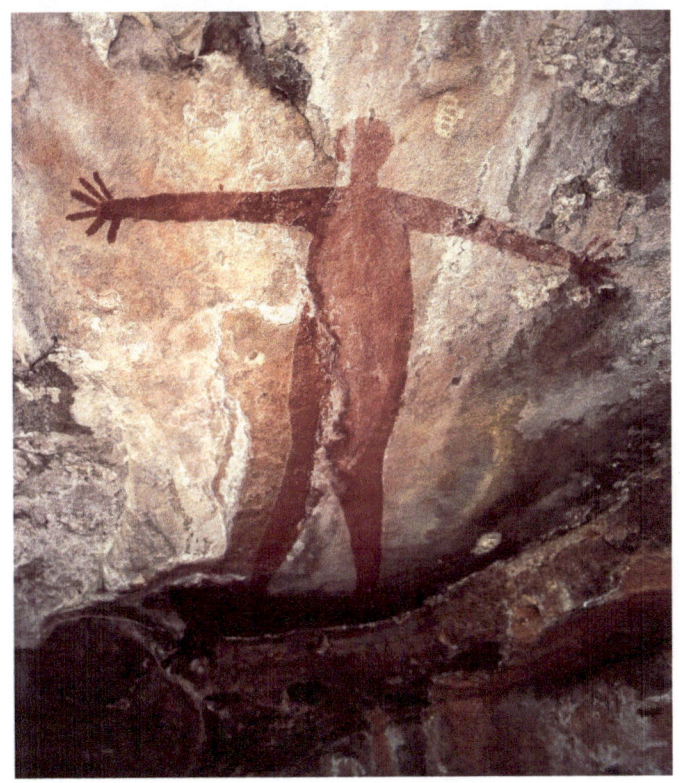

## Spirit Woman
*Cape York Peninsula*

Not far up the trail from *Emerging Man*, Mary brought us to the *Spirit Woman* shelter. Painted in white, and frontally depicted, except for her profiled breasts, the *Spirit Woman* reaches toward a yellow-ochre wallaroo on the gently sloping ceiling. The wallaroo is superimposed on earlier images, one a stiff-looking man speckled with dots. His long legs protrude to the right, and his right arm appears faintly beneath the wallaroo's front legs.

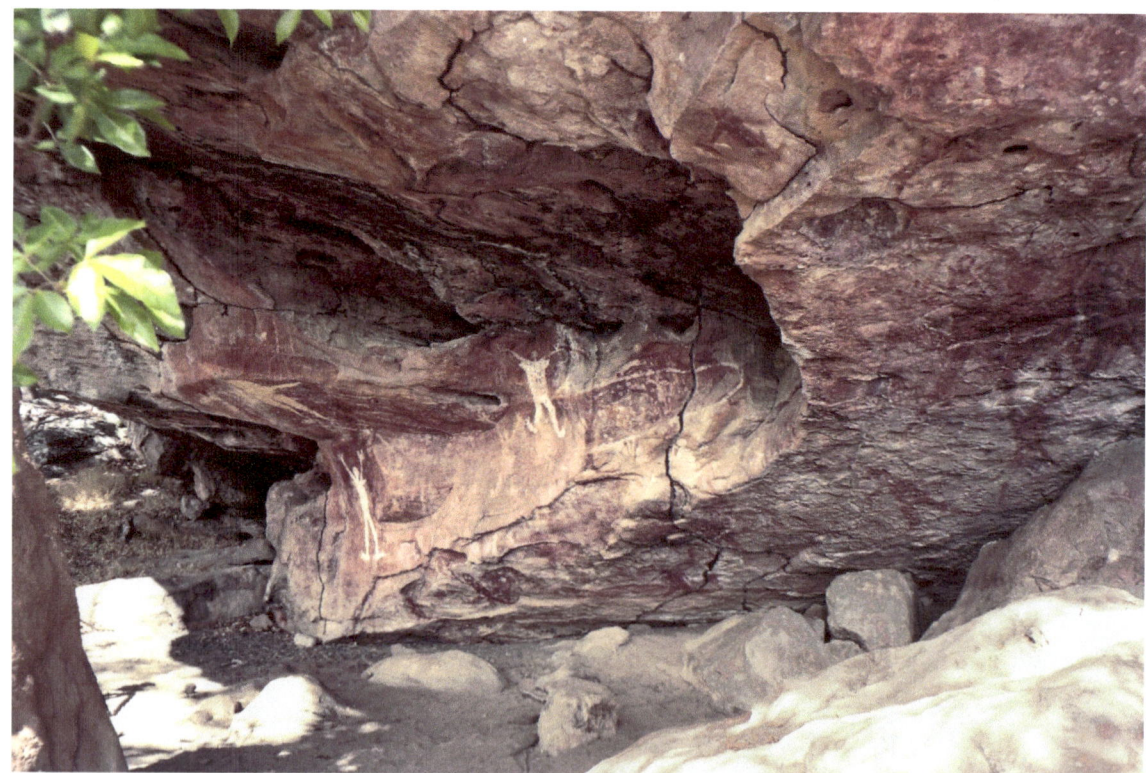

*Overview of the "Spirit Woman" shelter.*

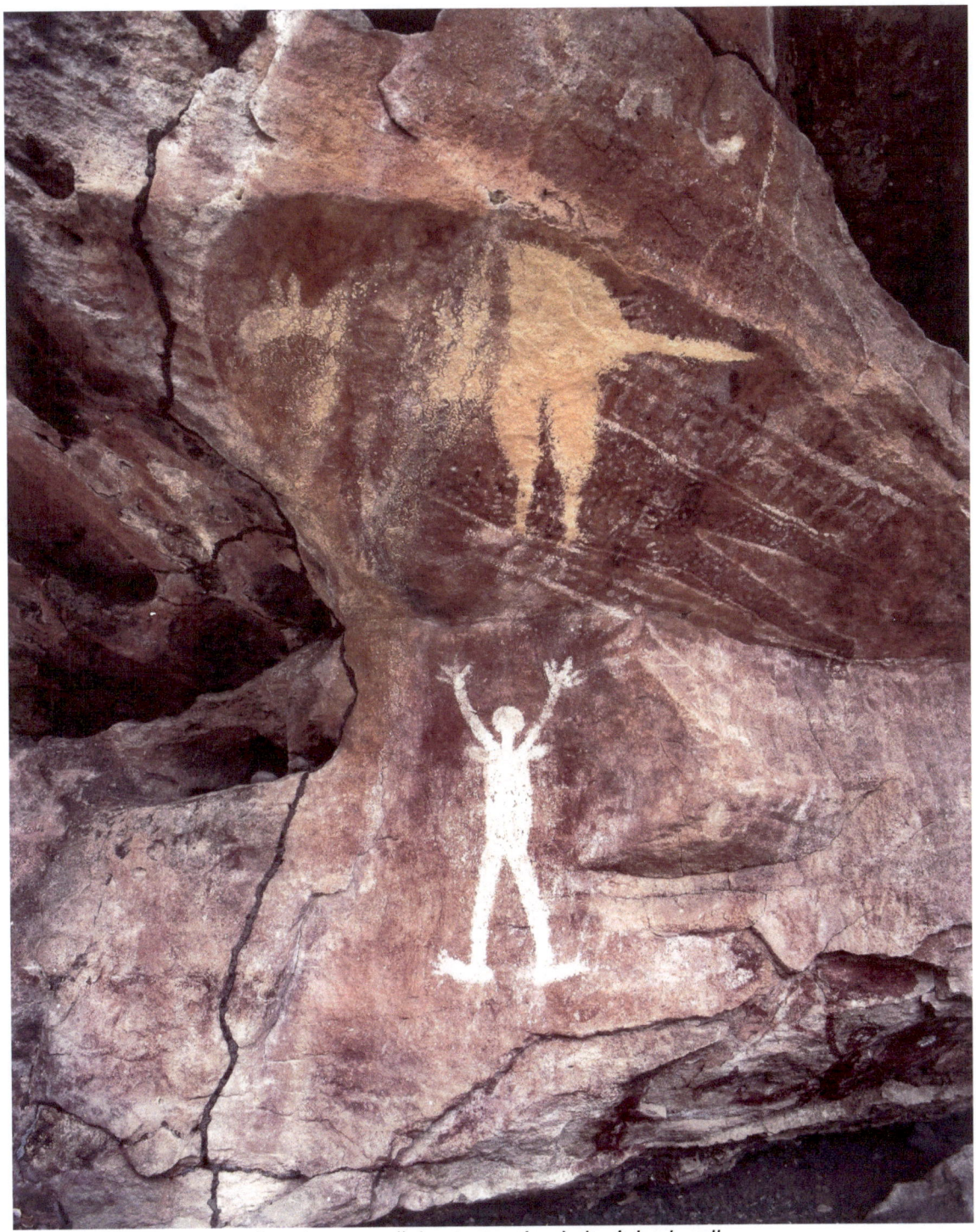
*"Spirit Woman" dominates the shelter's back wall.*

## *Red Lady*
*Cape York Peninsula*

The Jowalbinna Bush Camp covers some 25 square miles of tropical eucalyptus-covered hills topped with sandstone escarpments. Percy Trezise, a former bush pilot who passed away in 2005, spotted the cliff murals from the air in the 1950s–60s and subsequently purchased the land lease and built a homestead. Trezise was an artist, writer and amateur anthropologist. His two sons Stephen and Matthew still manage the camp.

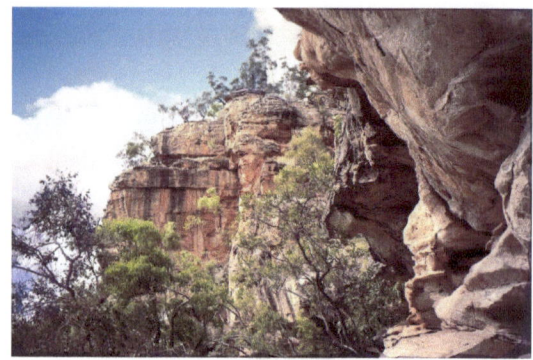

*The murals are scattered along the sandstone escarpments.*

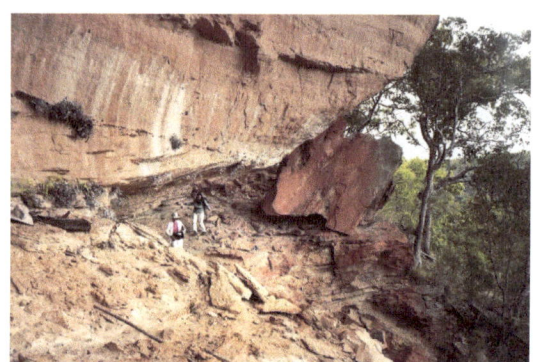

*Erma Martin Yost and Mary Haginikitas pick their way across a talus slope.*

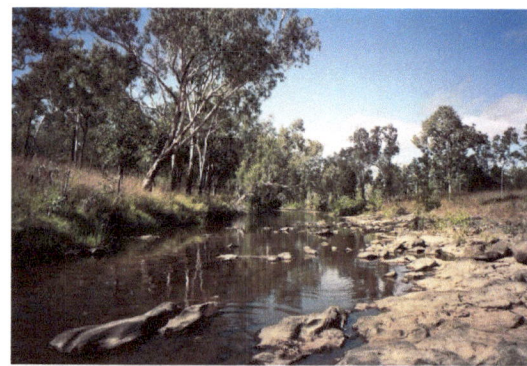

*Shepherd Creek flows through the valley below the pictographs.*

"Red Lady" is up the trail from "Spirit Woman," in a protected corner of the escarpment. She is roughly life size, painted in red, partially covering a dingo with her legs. Another dingo and large wallaroo approach from the left. ▷▷

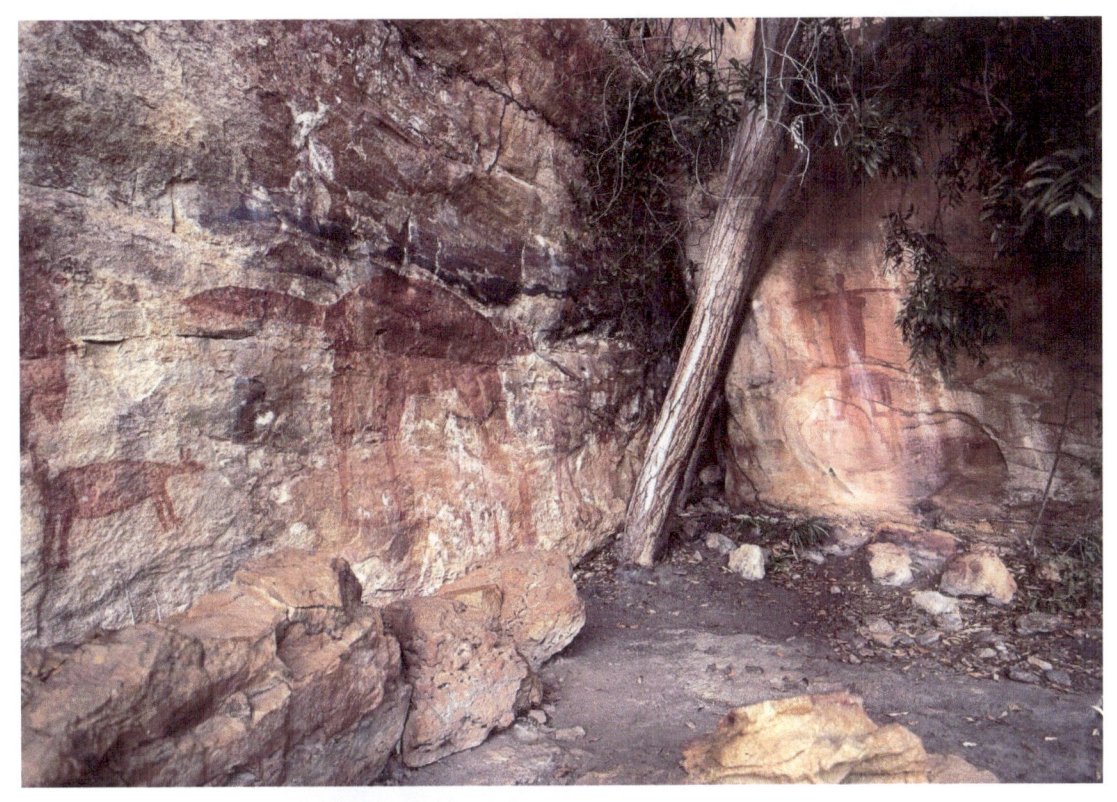

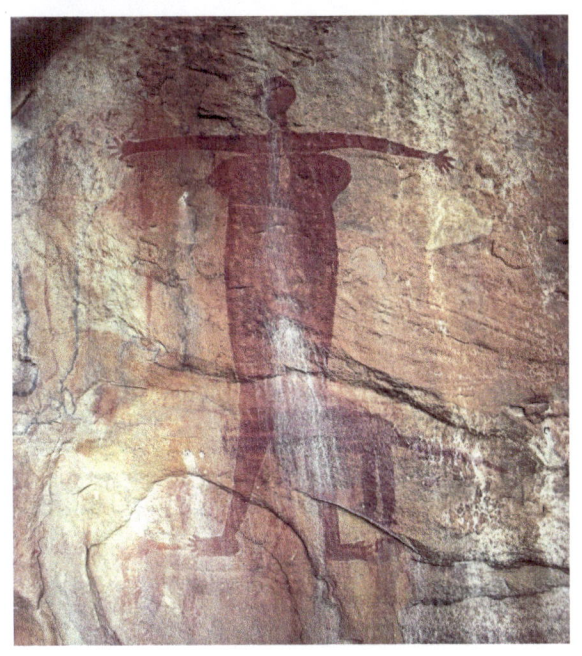

## *Levitating People*
*Cape York Peninsula*

The *Levitating People* are on the left side of a long mural on a high sandstone cliff. Layers of images from Aboriginal life crowd the rippled surface, end to end, reaching some ten or more feet from the ground. The red-bodied male and female figures are trimmed in white, and seem to be flying! I'm sure the makers had something else in mind, but it's hard to escape a 21st century westerner's interpretation. ▷

The commanding setting overlooks a broad valley with a similar sandstone escarpment topping the hills on the other side. ▽

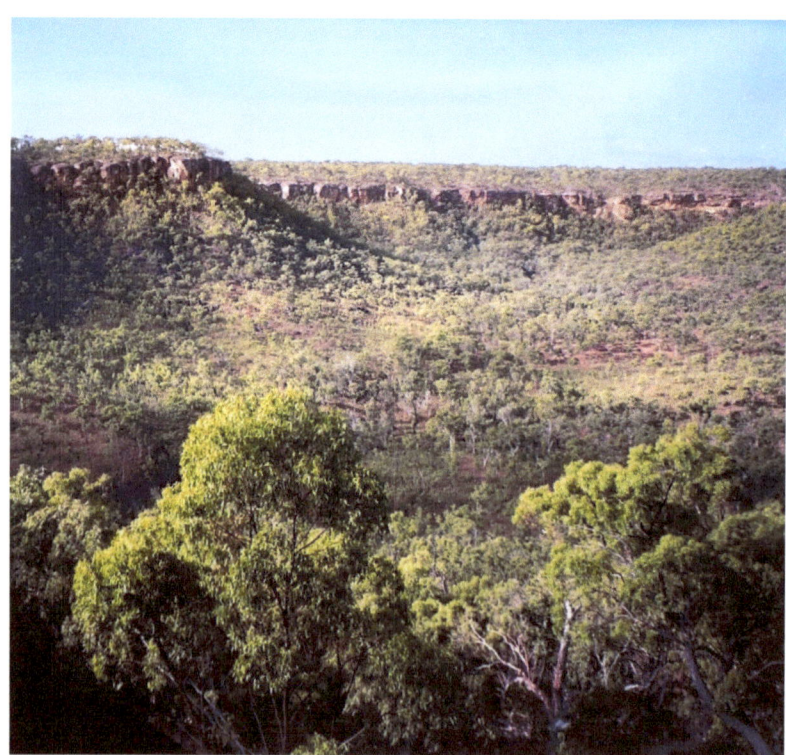

*View across the valley from the "Levitating People."*

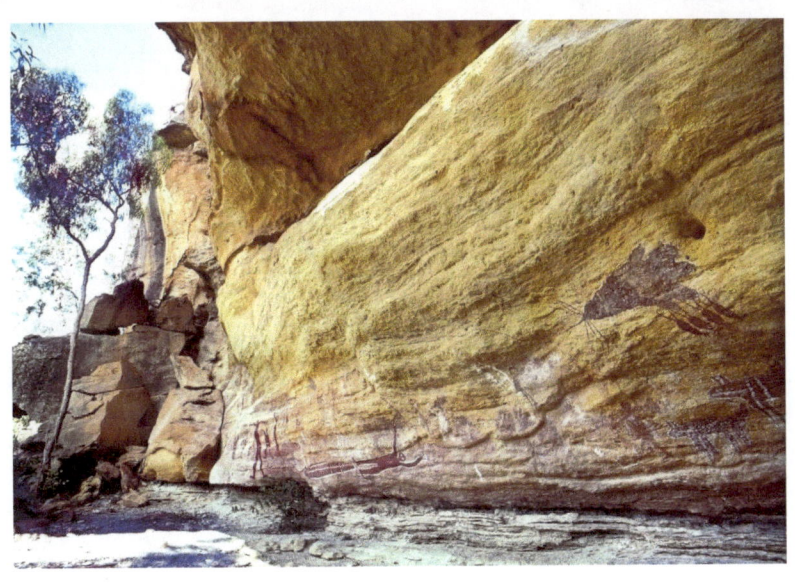

## *Guardian and Garfish*
*Cape York Peninsula*

The Guardian and Garfish shelters are formed of fallen boulders lodged halfway down the hillside. Eight-feet tall and expertly painted, the *Guardian* dominates a sheltered space under a tilted rock *(right)*. Three white garfish decorate a room-like chamber *(below)* with handprints, humans and water creatures. It's a seeming underwater composition with ripples in the rock looking like waves.

The red balloon-like form at the top is a catfish, identified by its forward-pointed feeler-hairs. The long-snouted white forms are the garfish—one at the bottom pointing his nose toward a horizontal man's phallus. We don't know why the man is swimming with the fishes but the Aboriginals would have had long handed-down stories to accompany the art. The stenciled handprints give scale. ▽

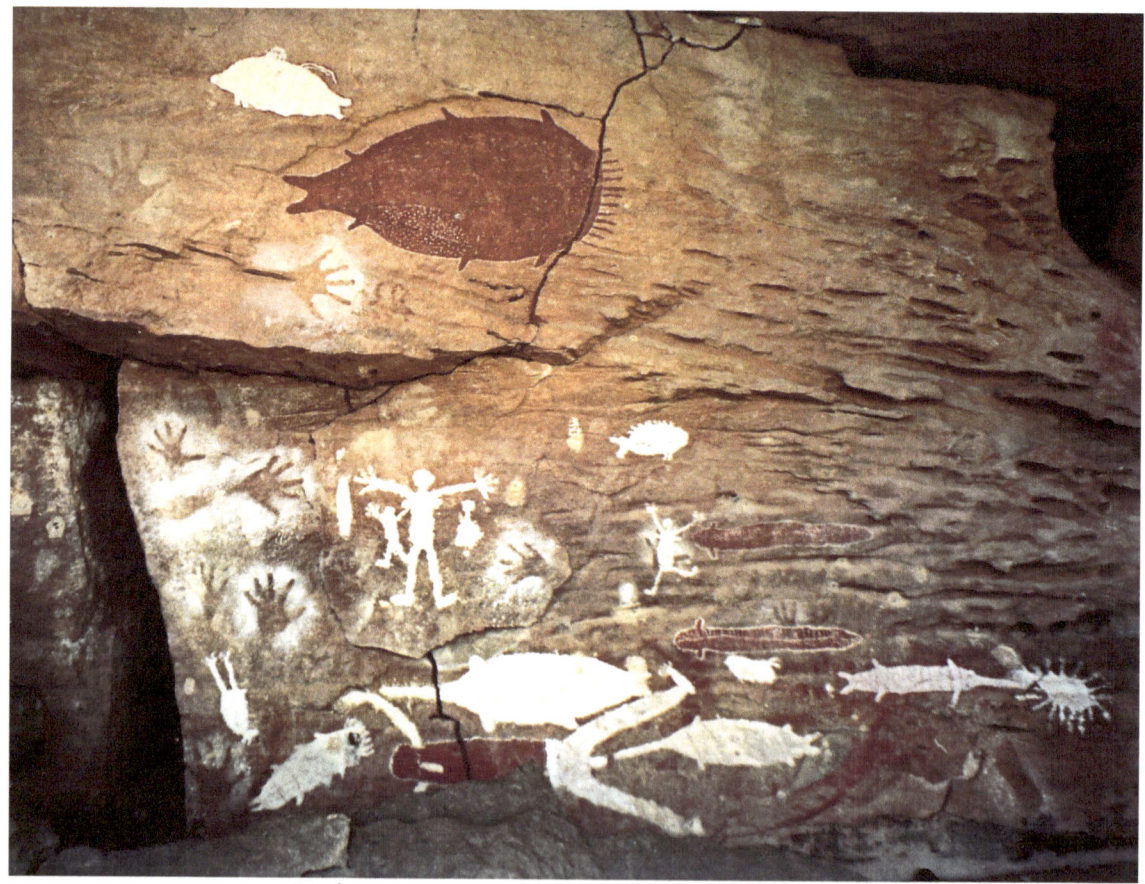

*Underwater scene with fish and a horizontal man.*

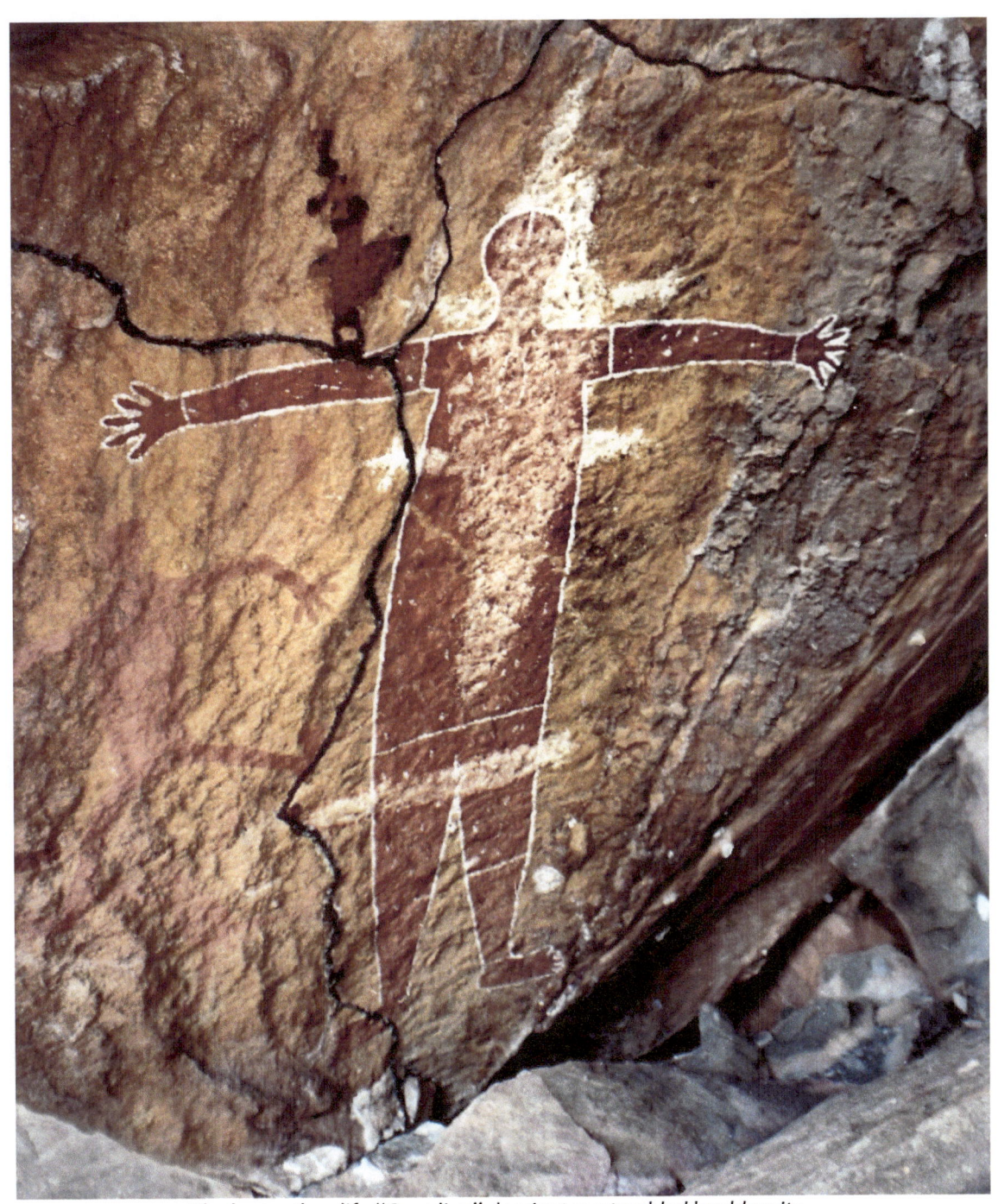
*The larger than life "Guardian" dominates a tumbled boulder site.*

## *Giant Wallaroos*
*Cape York Peninsula*

Giant red wallaroos, one chased by a white dingo, parade across adjoining sections of this wide cliff-face. Underneath is a natural chamber, just large enough to crouch in, that features even more paintings on its low smooth ceiling. A row of baseball-size cupules lines the lower edge of the cliff—possibly recording significant events. It's a profoundly powerful place that Aboriginals visited over long spans of time.

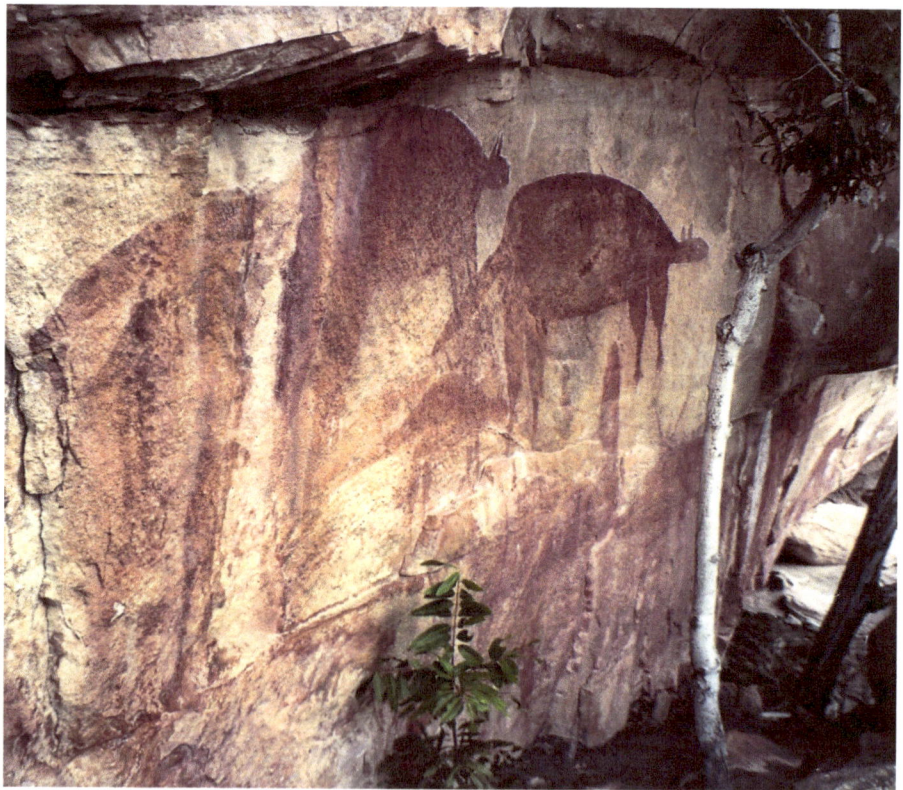

*"Giant Wallaroos" follow others around the bend.*

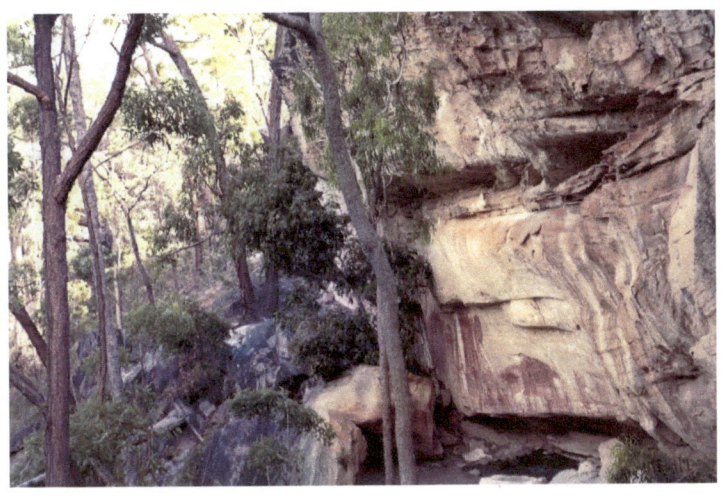

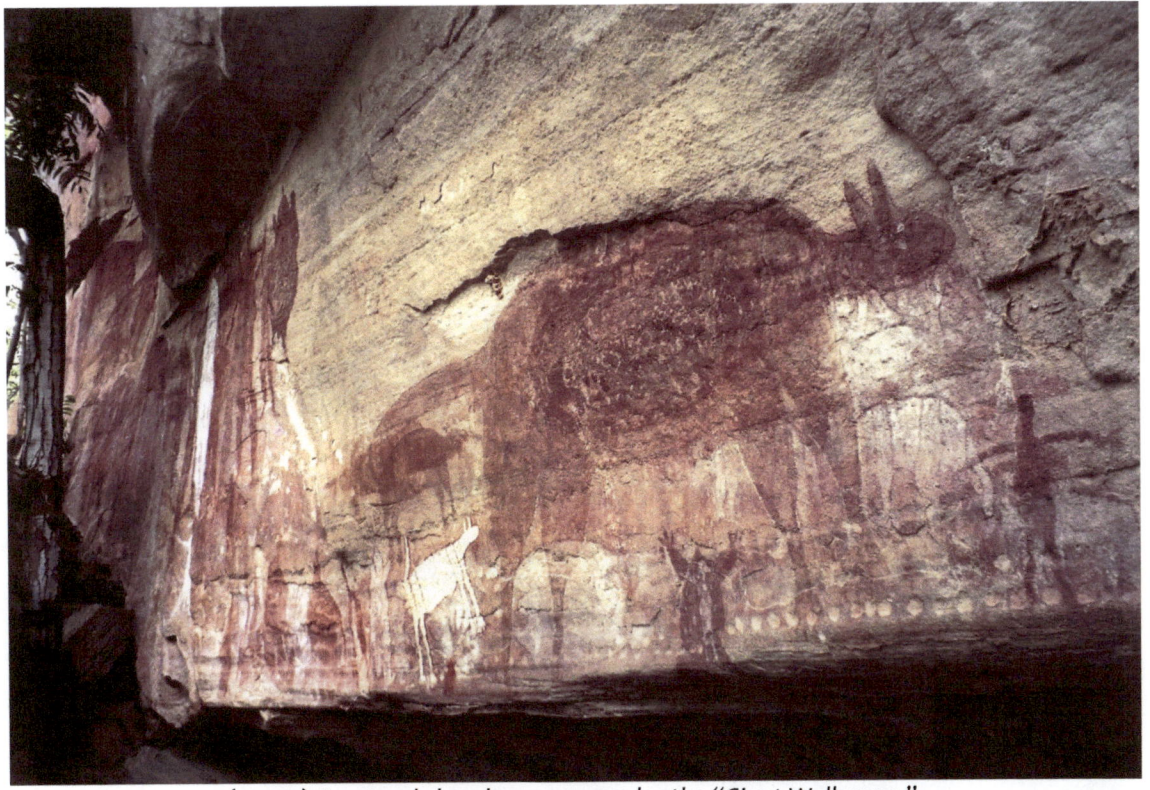

*(upper) A natural chamber opens under the "Giant Wallaroos."*
*(lower) A white dingo chases a giant wallaroo across the cliff.*

## Swirling Figures
*Cape York Peninsula*

When we stepped inside the shallow chamber at the *Giant Wallaroos (page 17)*, we saw swirling figures splayed across the ceiling just inches from our faces. There is no gravity in the compositions, but a strong sense of motion. They are small compared to the *Giant Wallaroos* outside, but in some ways even more evocative. A white spotted dingo lies on a woman in red, outlined in white–who is being bitten on the foot by a snake *(lower right)*. Below them, pointed in the opposite direction, is another dingo, more crudely painted, and more recent. ▷

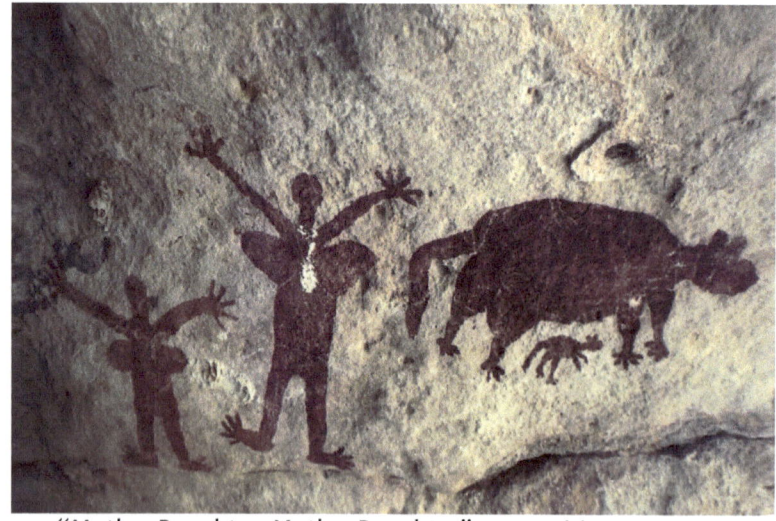

*"Mother Daughter, Mother Daughter" composition in a lower part of the chamber*

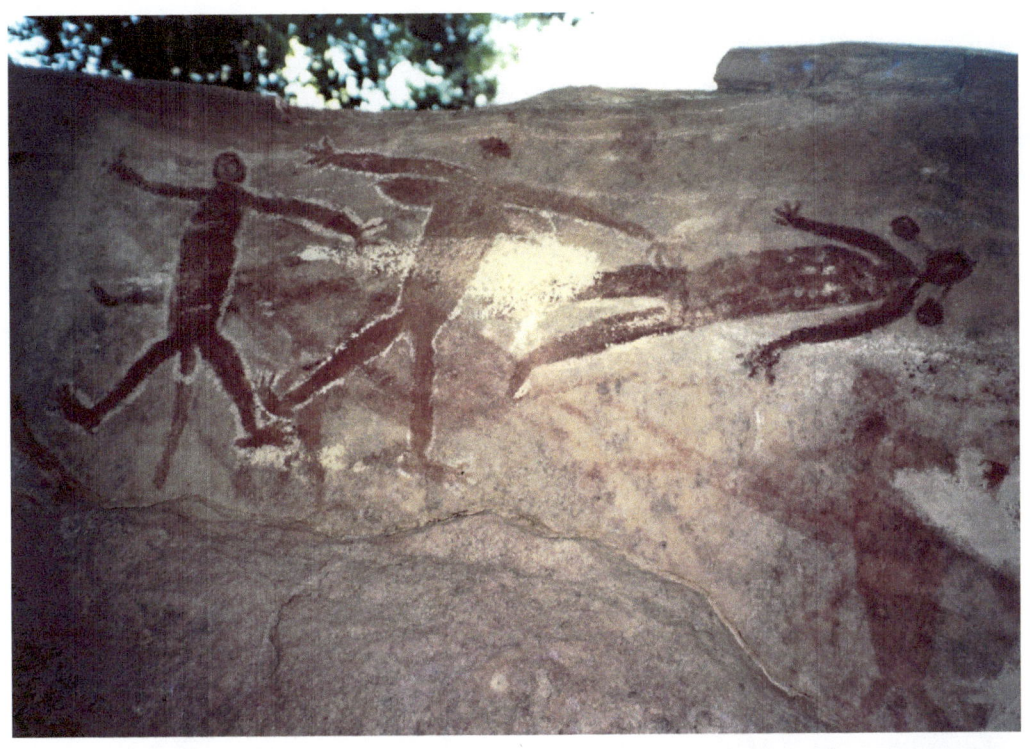

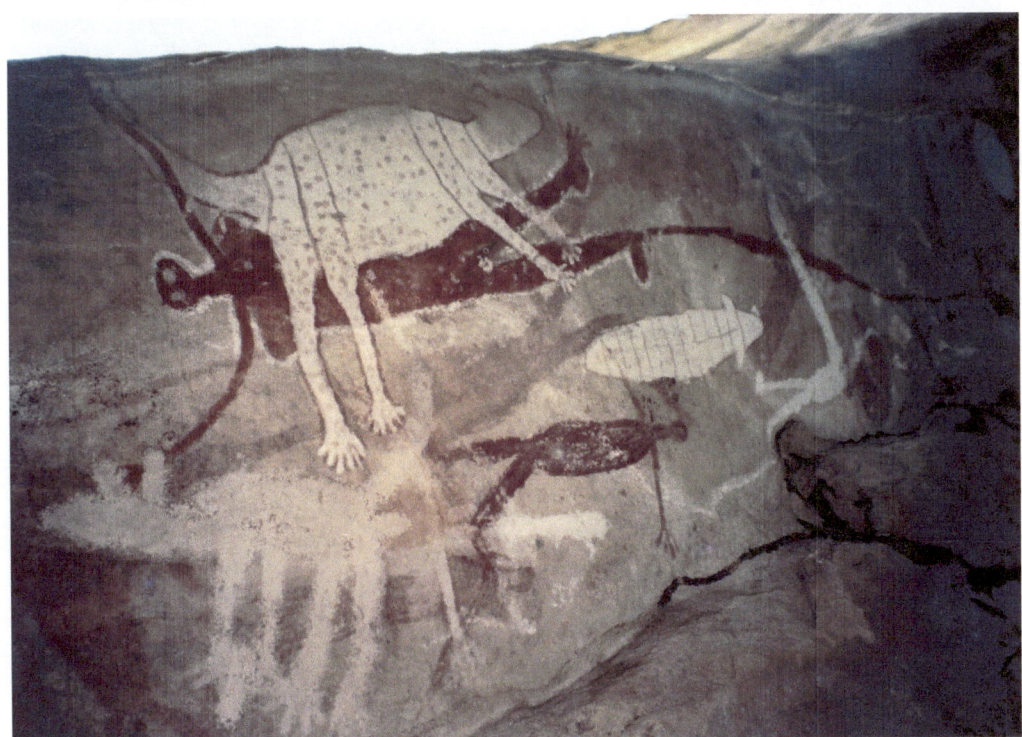

*Animals and humans swirl across the ceiling of the natural chamber.*

## *Hovering Quinkin*
*Cape York Peninsula*

*Hovering Quinkin* is a detail from a major mural at the towering *Red Bluff* site. The art extends some 100-yards along the base of a sandstone outcrop, thrusting up from the valley floor. It's a picturesque place of high cliffs and vibrant red/orange color.

The Quinkin is the white figure with curved arms, hovering above the red man/woman/child group. Quinkins are spirits who live in the rocks, traveling in and out of the cracks. ▷

*The Red Bluff pictograph mural is some 100-yards long.*

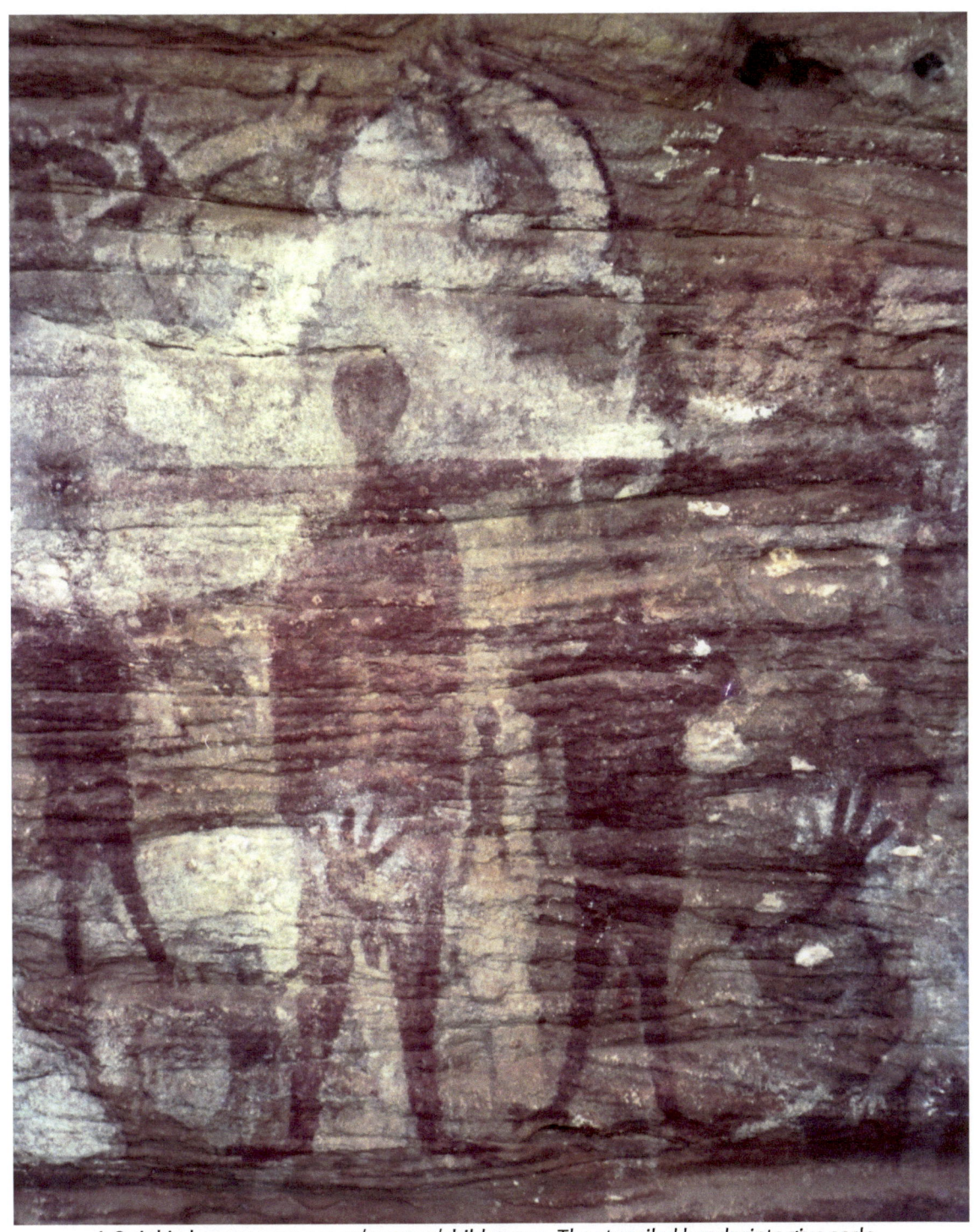
*A Quinkin hovers over a man/woman/child group. The stenciled handprints give scale.*

## *Red Matriarch*
*Cape York Peninsula*

The *Red Matriarch* is a powerful woman standing at the base of the *Red Bluff* outcrop. Larger than life, she is rendered in red, outlined in white and covered with stenciled hands. You can estimate her size by comparing the stenciled *(actual)* human handprints with her drawn and painted right hand. Small animals and people cluster around her as if attracted by her power. The sandstone is unusually rough here, but the artists took care to paint inside each indentation to visually anchor the forms to the rock's surface. ▷

*The Red Bluff thrusts up from the surrounding landscape.*

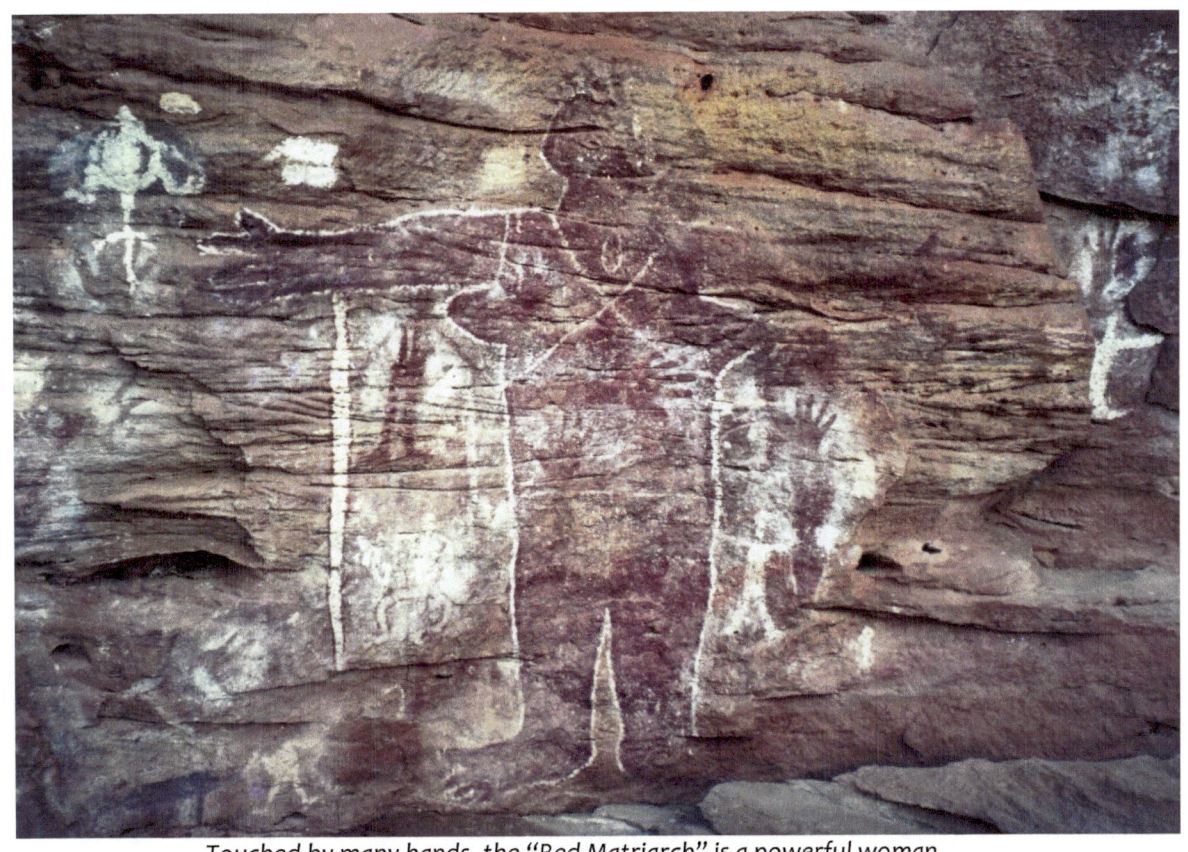
*Touched by many hands, the "Red Matriarch" is a powerful woman.*

## Flying Man, Flying Woman
*Cape York Peninsula*

These two panels adorn the ceilings of two shallow caves near the *Red Bluff*. The flying man is painted in an unusually vibrant orange, the only example of this color we've seen. His head overlays a red quadruped, suggesting he's a later addition, and his left hand has five fingers. His right has four, and his toes are turned-in. It's an expressively painted, gravity-free composition by skillful artists! ▷

The *Yellow Woman* is also unusually vibrant— painted in yellow ochre, outlined in red. She's alone on the small cave's ceiling, except for a large eel at her left side. She displays a traditional headdress, and her enlarged breasts may indicate she is nursing? ▽

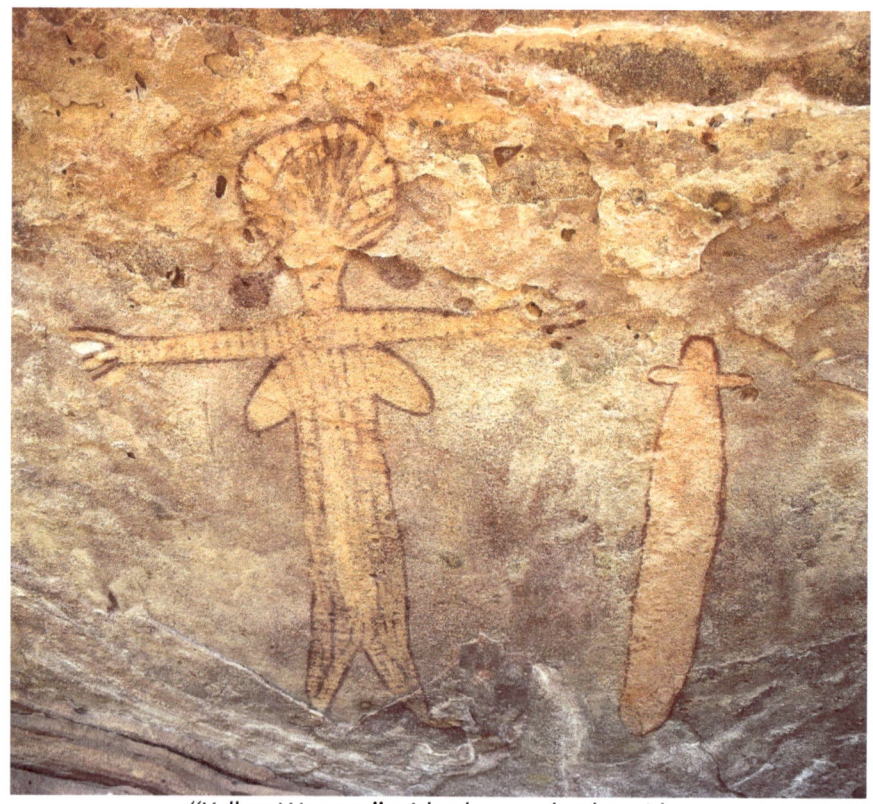

*"Yellow Woman," with a large eel at her side.*

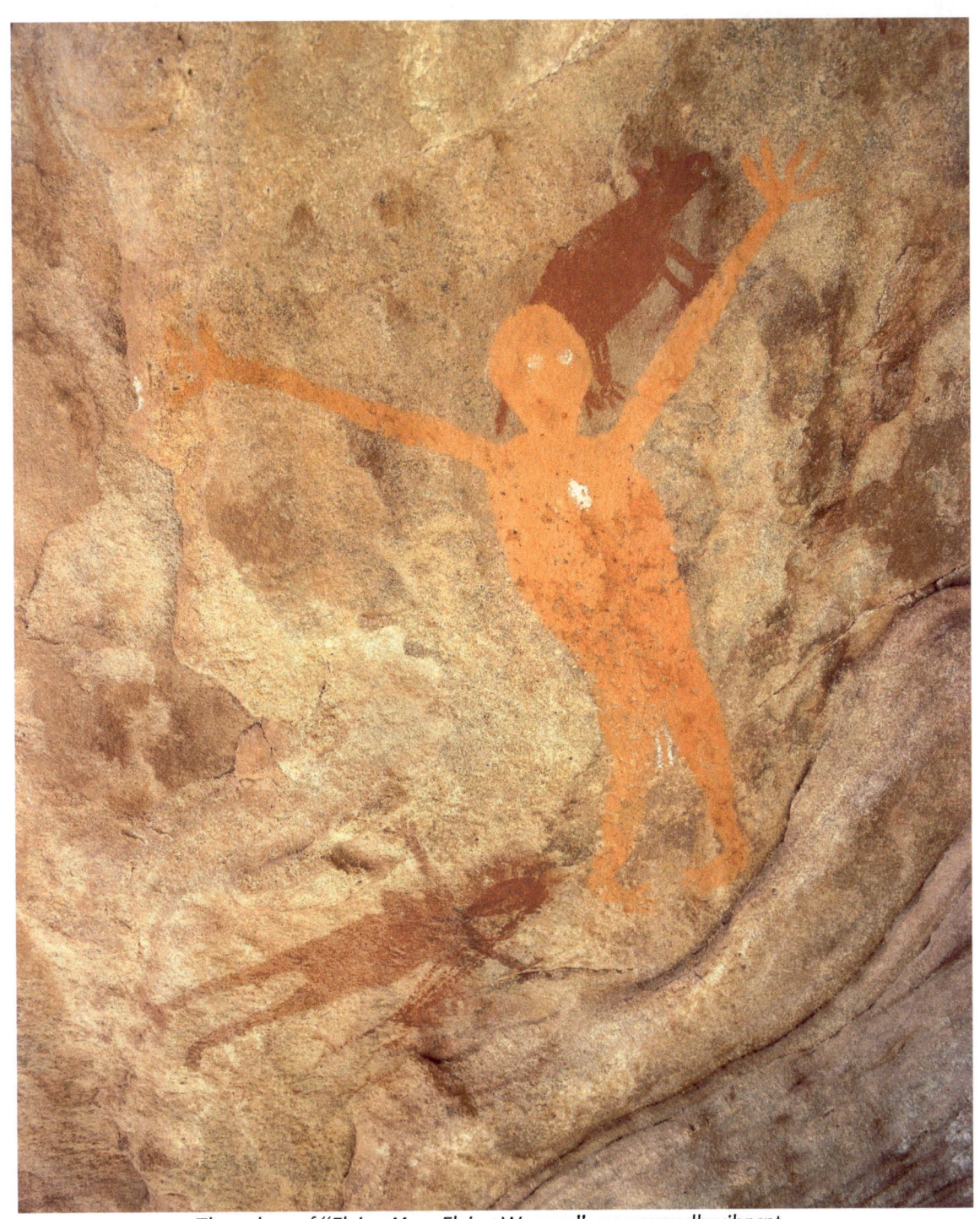
*The colors of "Flying Man, Flying Woman" are unusually vibrant.*

## *West to Willeroo*
*Wardaman Tribe, Northern Territory*

Wardaman tribal land is in the northwestern part of Australia's Northern Territory, an hour and a half southwest of Katherine via the Victoria Highway. It's semi-arid country, mostly flat, with two seasons, the wet and the dry–and the temperature is warm to hot year-round. The highway passes through groves of eucalyptus trees rising from golden spinifex grass. Occasional burning clears the brush, providing good visibility and easy walking. Sun-baked termite mounds fill the spaces between the trees like stands of silent sentinels–and rose-breasted cockatoos flutter overhead, catching the morning light. ▷▷

We arrived at the Willeroo Bush Camp mid-morning on July 5, 1993, and soon, our guide, Yidumduma, had us in the land rover, ready to find the rock art. Yidumduma is the last initiated male elder of the Wardaman tribe. The Wardamans have no written language and Yidumduma holds their history in his head–using the pictographs to recall the ancestral stories. ▷

*A huge boab shades the Willeroo Bush Camp. Its trunk holds enough water from the wet season to last through the dry.*

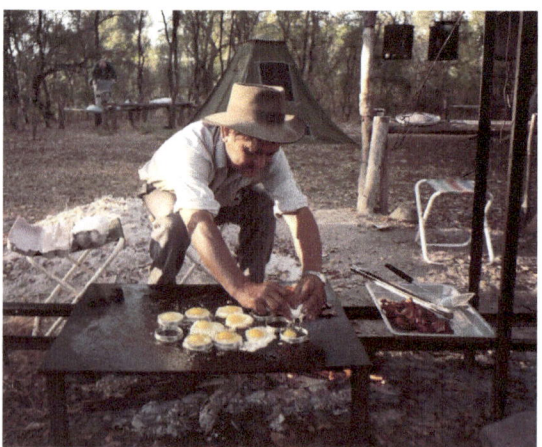

*Yidumduma cooks breakfast the morning of the second day.*

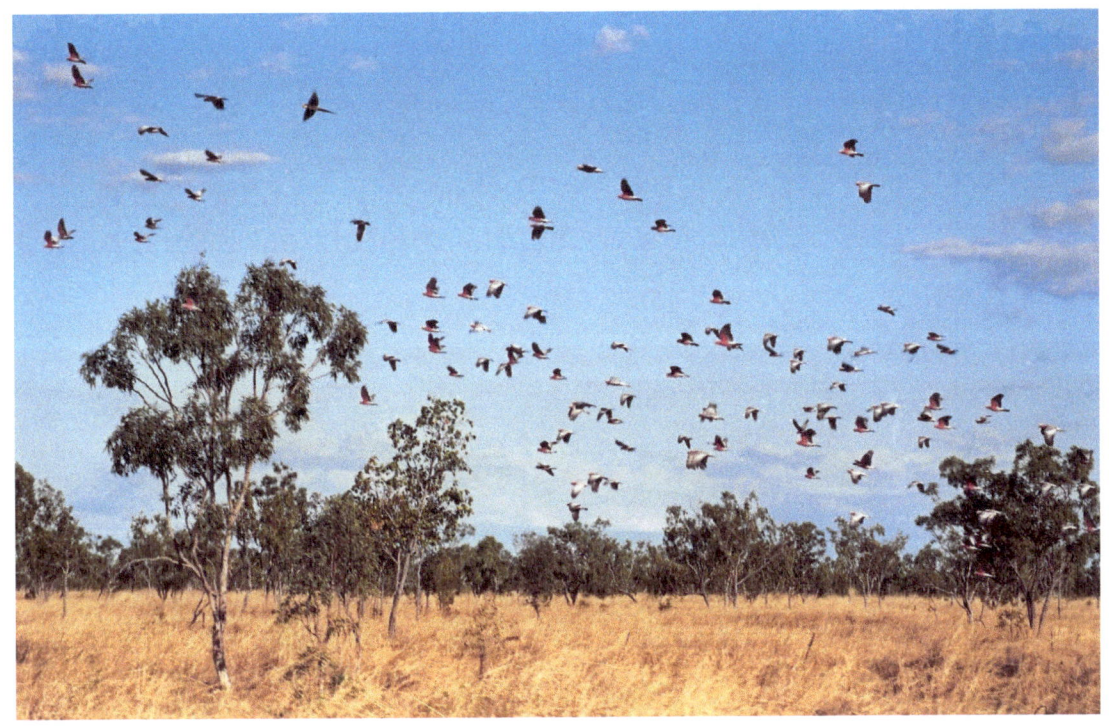
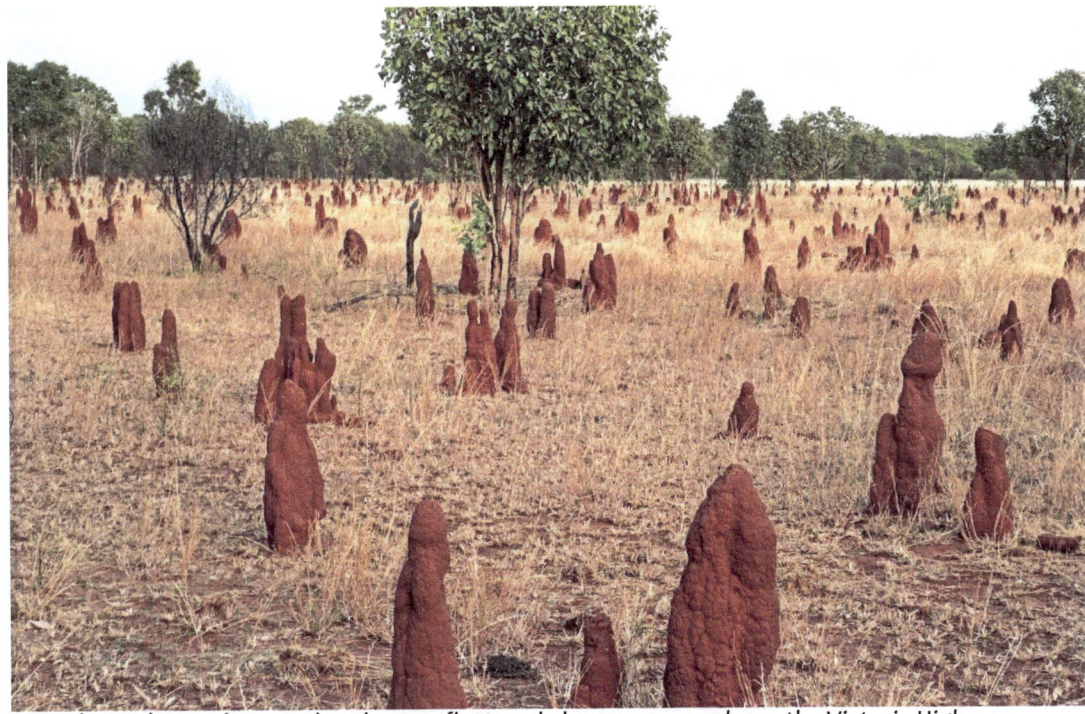

*(upper) Rose-breasted cockatoos fluttered above us as we drove the Victoria Highway.
(lower) We passed wide expanses of termite mounds standing like silent sentinels.*

## *Lightning Brothers*
*Wardaman Tribe, Northern Territory*

The *Lightning Brothers* are spirits who make it rain. In the creation time, when the rocks were soft, they were regular people walking around, but later when the rocks hardened they were fixed in place—and they're still there today. Initiated elders *sing* at this site to bring the rain at the end of the dry season. The yellow spirit, Jabiringi, brings the tornado and cyclone and the red spirit, Yagjagbula, brings the thunderstorm. The black stripe through the center of each spirit is a power line that ends with a white puff at its tip representing the puff of smoke when lightning hits the ground. The two stone axes in Yagjagbula's hands crash together to make thunder and forked lightning that splits trees.

Although it is frowned upon today, some elders still have the power to throw lightning, using it as a weapon.

Wardaman children are taught never to wear yellow or red during a storm because those are the *Lightning Brothers'* colors and wearing them could cause lightning to strike them—and men don't use axes in the rain for the same reason.

We asked Yidumduma if he knew the rain songs. He said yes but couldn't demonstrate because that would cause trouble. But he sang us a different song to illustrate the sound. It was a rhythmic chant, somewhat syncopated, timed by slapping his leg.

Yagjagbula carries a law stick on his left, used to discipline people who break the law. The law is considered "good" because it insures the tribe's survival. The red bars on Jabaringi's shoulders are clan symbols.

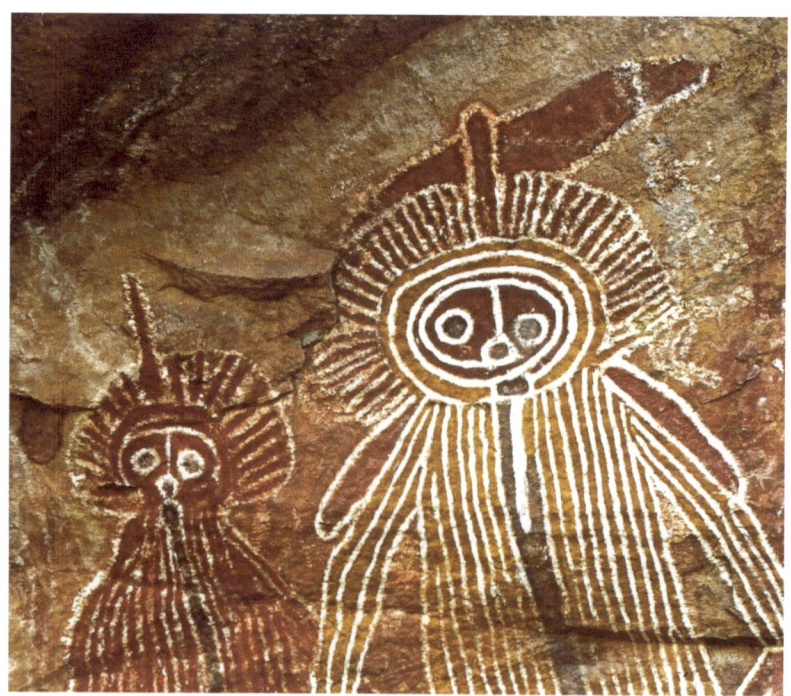

*Yagjagbula, (left) brings the thunderstorm and Jabiringi, (right) brings the tornado and cyclone.*

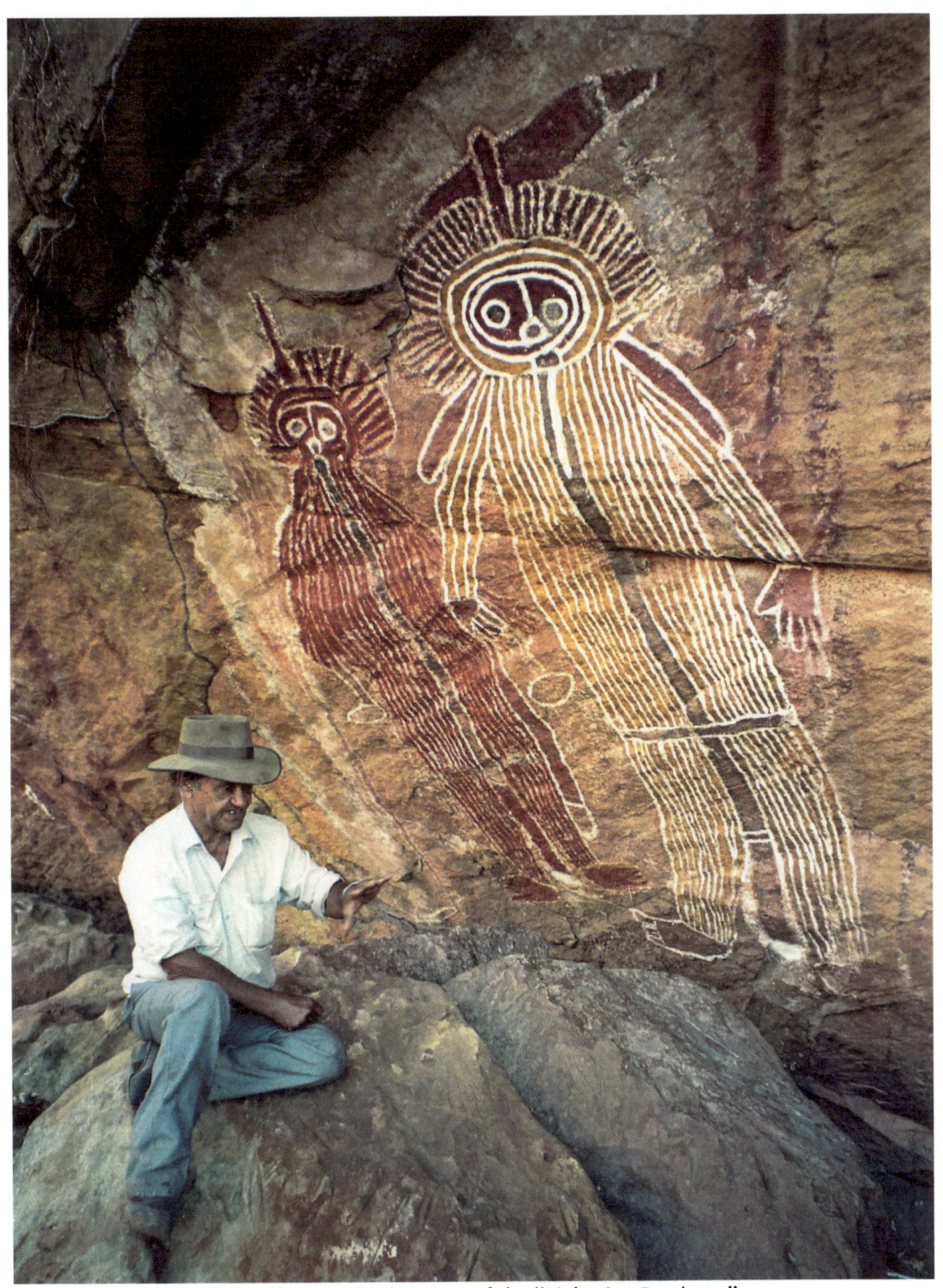

*Yidumduma, tells the story of the "Lightning Brothers."*

## *Young Lightnings*
Wardaman Tribe, Northern Territory

In this packed composition, some 30-feet wide, two mature lady lightnings rise from a mob of "young ones coming on." Lady lightnings have different headdresses from the men. ▷

A natural overhang creates a room-like space for the paintings, protecting them from the elements. More than 90 young lightnings crowd the red sandstone wall below a cluster of mature lightning people *(in the left orange area)* that have faded over time. The spirits lose their power when they fade, so the Wardamans periodically hold ceremonies to repaint them.

Yidumduma said (approximate quote), "we sing while we draw—faster and faster . . . we don't go over the line." And he told us they don't add *new* images at sites like this. They only paint back the old ones.

Artistically, this is in the classic Wardaman art style, bold and visually vibrant, with white lines set against contrasting colors. There is primordial power in the archetypal faces, *(lower right)* inviting comparisons to Edvard Munch's famous *The Scream* series.

Subsequent to our visit in 1993, several of the faded images on the left have been repainted. ▷

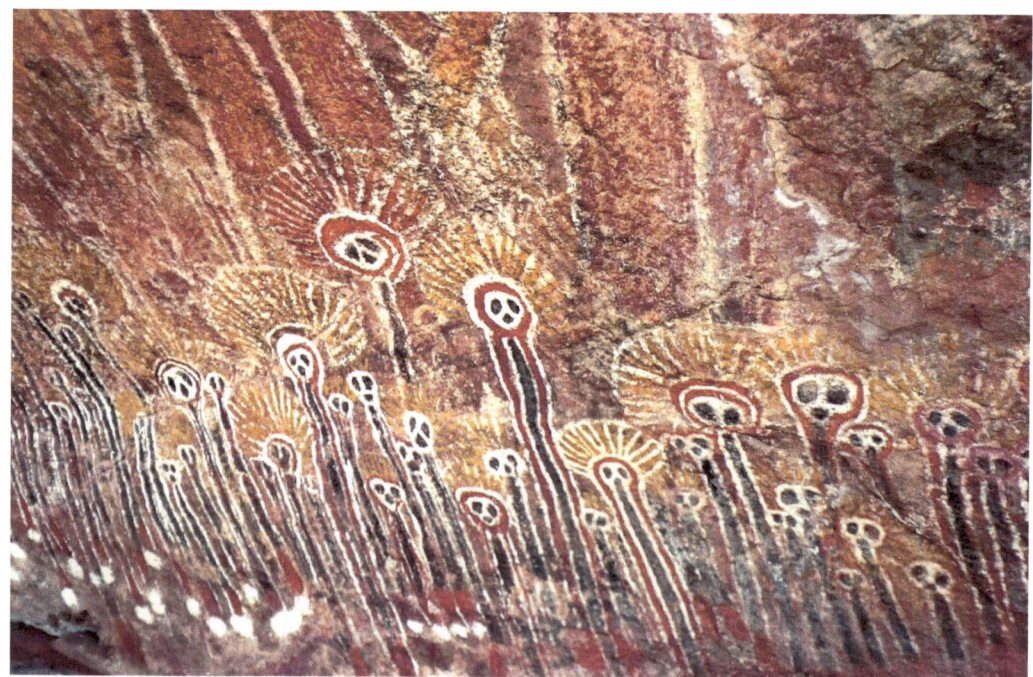

*More than 90 "Young Lightnings" crowd the red-stained wall.*

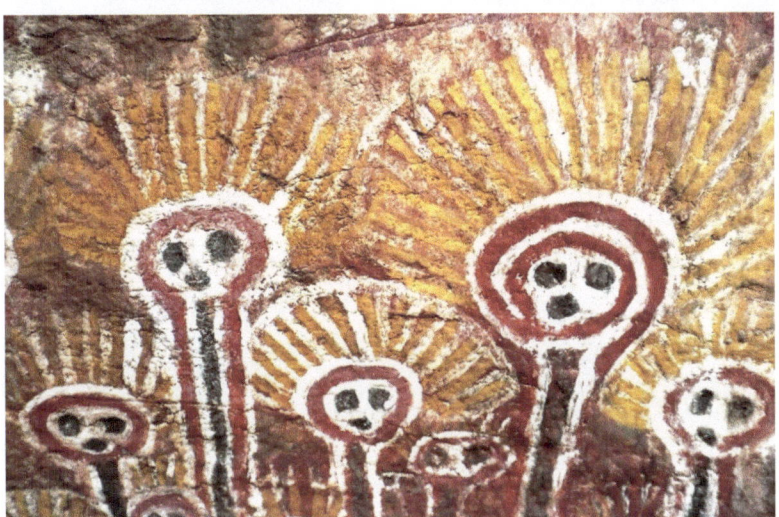

*(upper) Two lady lightnings rise from a mob of young ones.*
*(lower) Archetypal faces with no noses project primordial power.*

# *The Life Cycle*
*Wardaman Tribe, Northern Territory*

The Life Cycle pictograph is at the outer edge of the Young Lightnings shelter *(previous page)*. We entered the area through a low opening in a sandstone dyke, being careful not to bump our heads as we passed through. ▷

A pictograph of a pregnant woman is on the wall above a shallow chamber, where a shadowy phallic male clings to the ceiling. ▷

To her left, outside the photograph, a bleached human skeleton is neatly stacked on a rock ledge *(not pictured out of respect for the deceased)*. Yidumduma explained that it had been there for years because the relative authorized to carry it to its final internment had died.

In this tribe, a person's remains are brought to two temporary resting places for about a year each before the third and final internment, and only a specifically designated relative is permitted to carry them. As a result those bones will stay permanently on that ledge.

On the shelter's floor under the pictographs, vulva-like cavities are carved and painted into this egg-shaped boulder. Above them, linear markings track family bloodlines to avoid intermarriage when selecting spouses. *(You can see the boulder's location on the far right of the upper photograph on page 31).* ▽

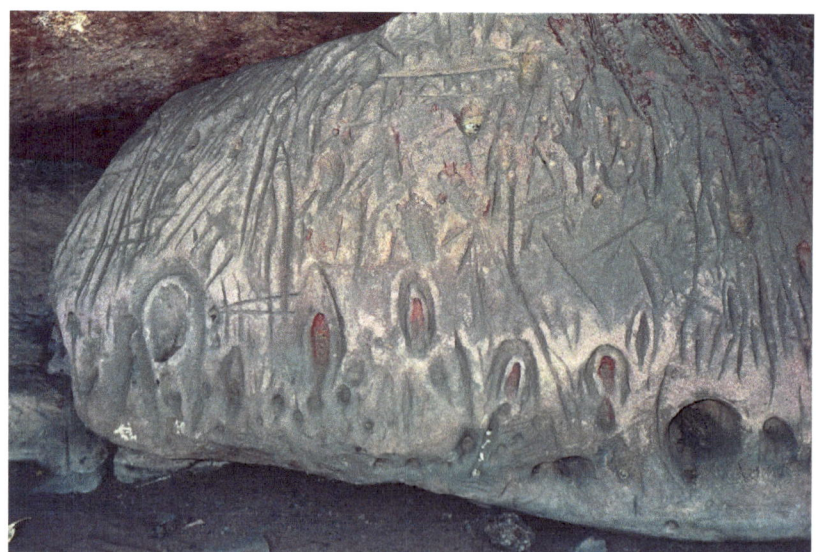

*Every surface of this egg-shaped boulder is carved or painted.*

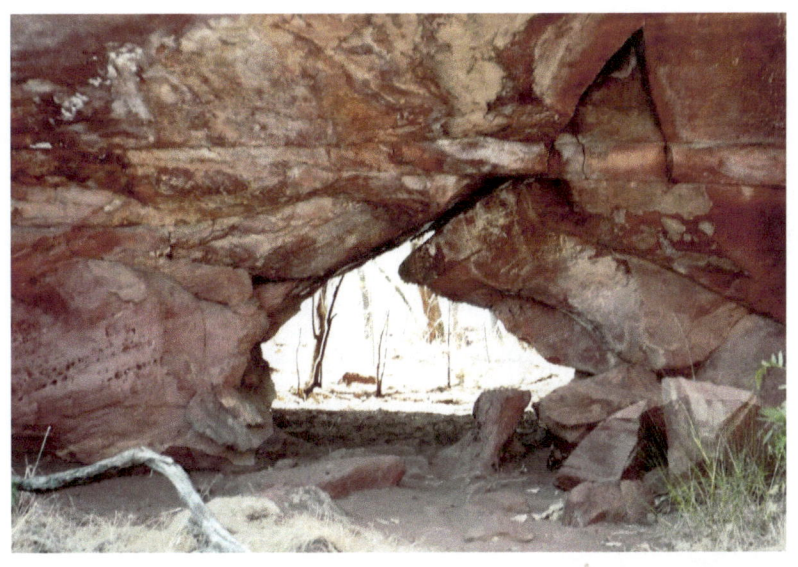

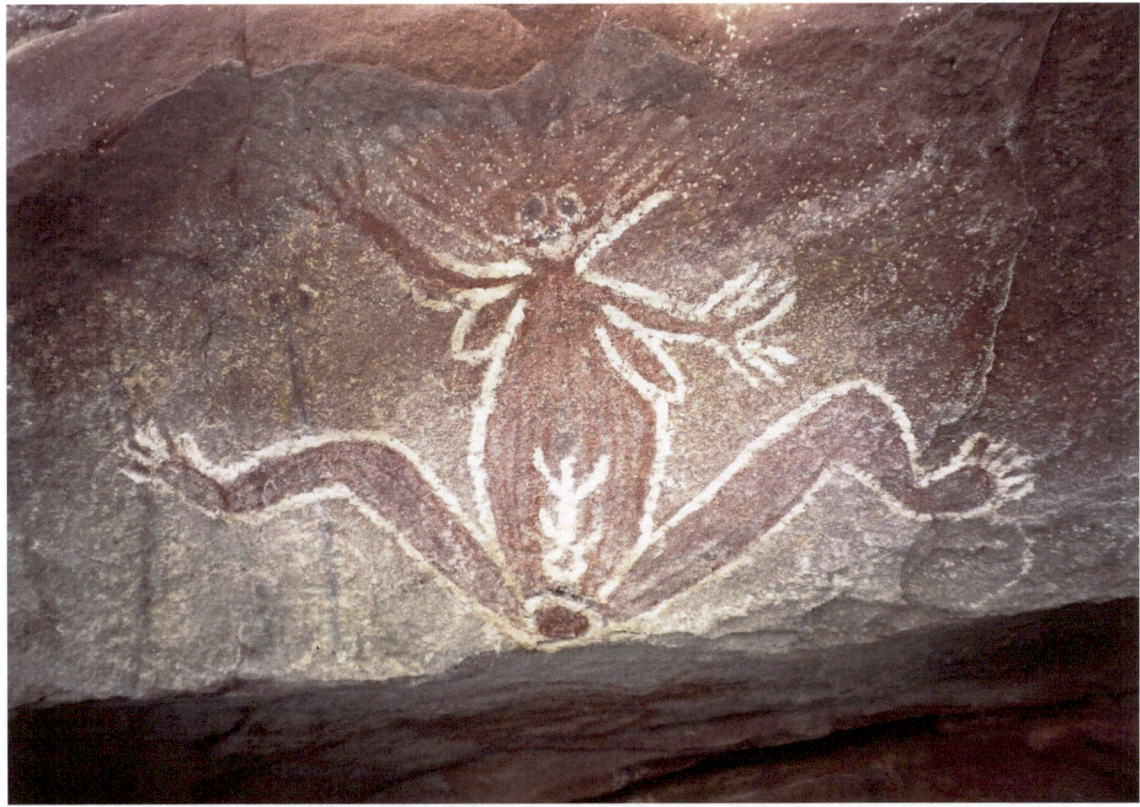

*(upper) We approached the shelter through this low opening in a sandstone dyke.*
*(lower) The pregnant woman is positioned above a shadowy phallic male.*

## Guardian Matriarch
*Wardaman Tribe, Northern Territory*

In the Wardaman tribe, parents of the bride and groom arrange the marriages and women record the bloodlines with incised grooves on the rocks. To avoid intermarriage, people are divided into four *skins*, and it's necessary to marry outside your own skin. Individuals have similar marks on their shoulders–made by scarification with sharp stones–so others can easily identify them. "Everyone has to have a mark," Yidumduma said. "Boys and girls get them at age 17. The stone numbs the skin."

A young man or woman is married to an old woman or man for their first marriage so that the young person can learn the facts of life from the elder. Yidumduma told us that at age 17 he was married to a 90-year-old woman. He said he is now married to his third wife but is still waiting for his *young* one. It is customary to be married to several spouses at the same time and there is no divorce.

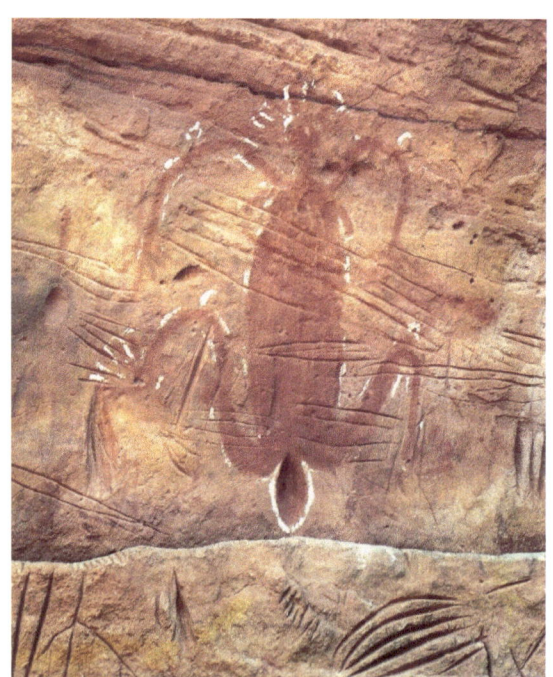
*Scratch marks record family bloodlines.*

*Overview of the "Guardian Matriarch" site.*

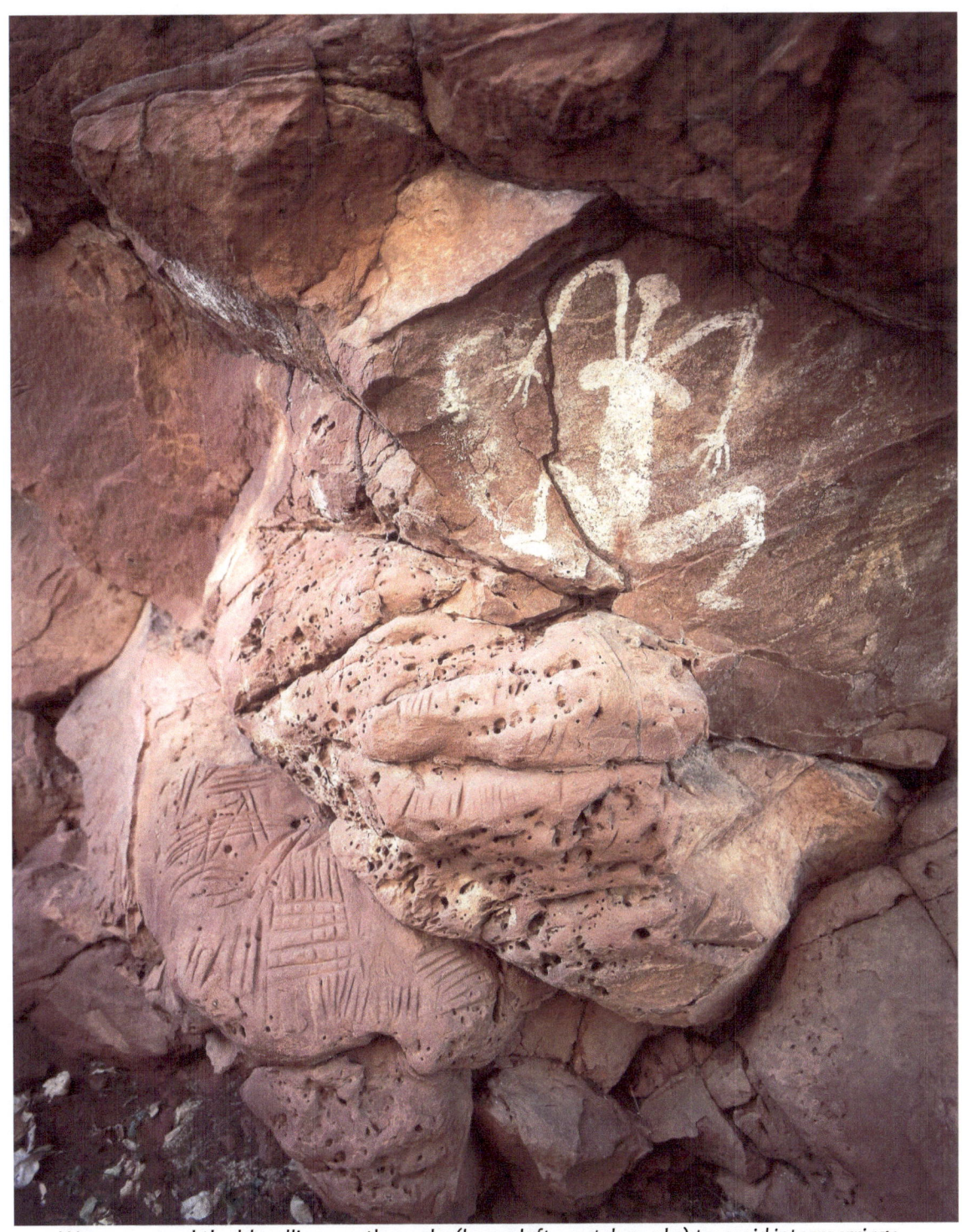
*Women record the bloodlines on the rocks (lower left scratch marks) to avoid intermarriage.*

## *Maravanna Lady*
*Wardaman Tribe, Northern Territory*

Here are two stories Yidumduma told us about the *Maravanna Lady*. One is for girls and the other for boys.

The *Maravanna Lady* sits on a young woman's head when she sleeps and puts a song there, which when she awakens she can't stop singing–and when she sings it she wants to become pregnant.

There is also a ceremony for young boys who are approaching initiation. In this ceremony, held at night, an old woman dances in the firelight.

She has no clothing except for feathers tied around her knees and elbows. She dances in a sexually explicit manner in order to teach the boys the facts of life. *Maravanna Lady* depicts this dance and that explains her hyperkinetic pose. Yidumduma said, "she is having a very good time." The bumps on her knees and elbows represent feathers she uses during the dance. When we asked Yidumduma how the boys react, he told us they act uncomfortable and giggle. ▷

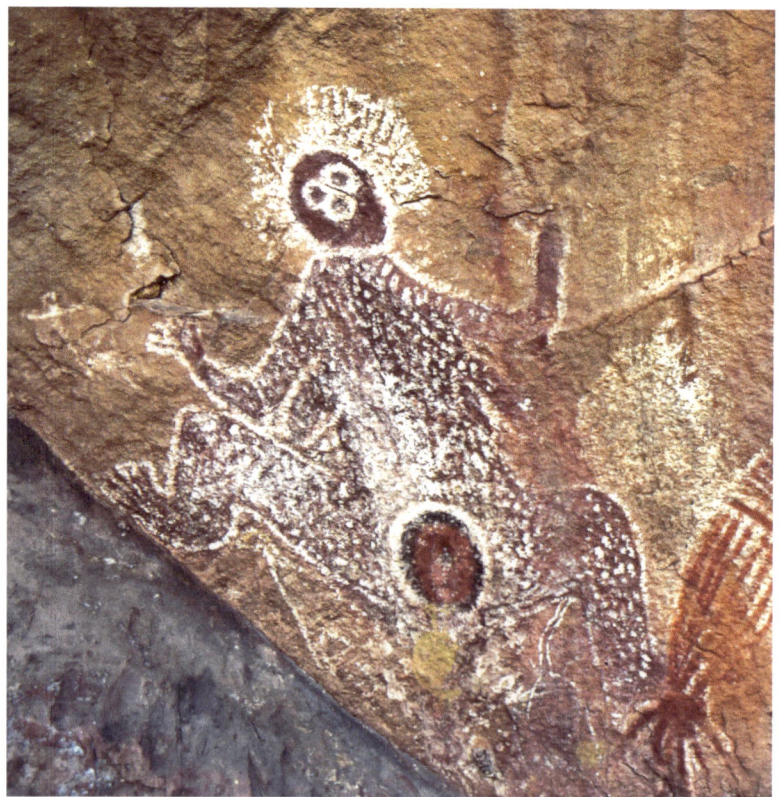

*Dotted woman from "Fertility Place" (page 38).*

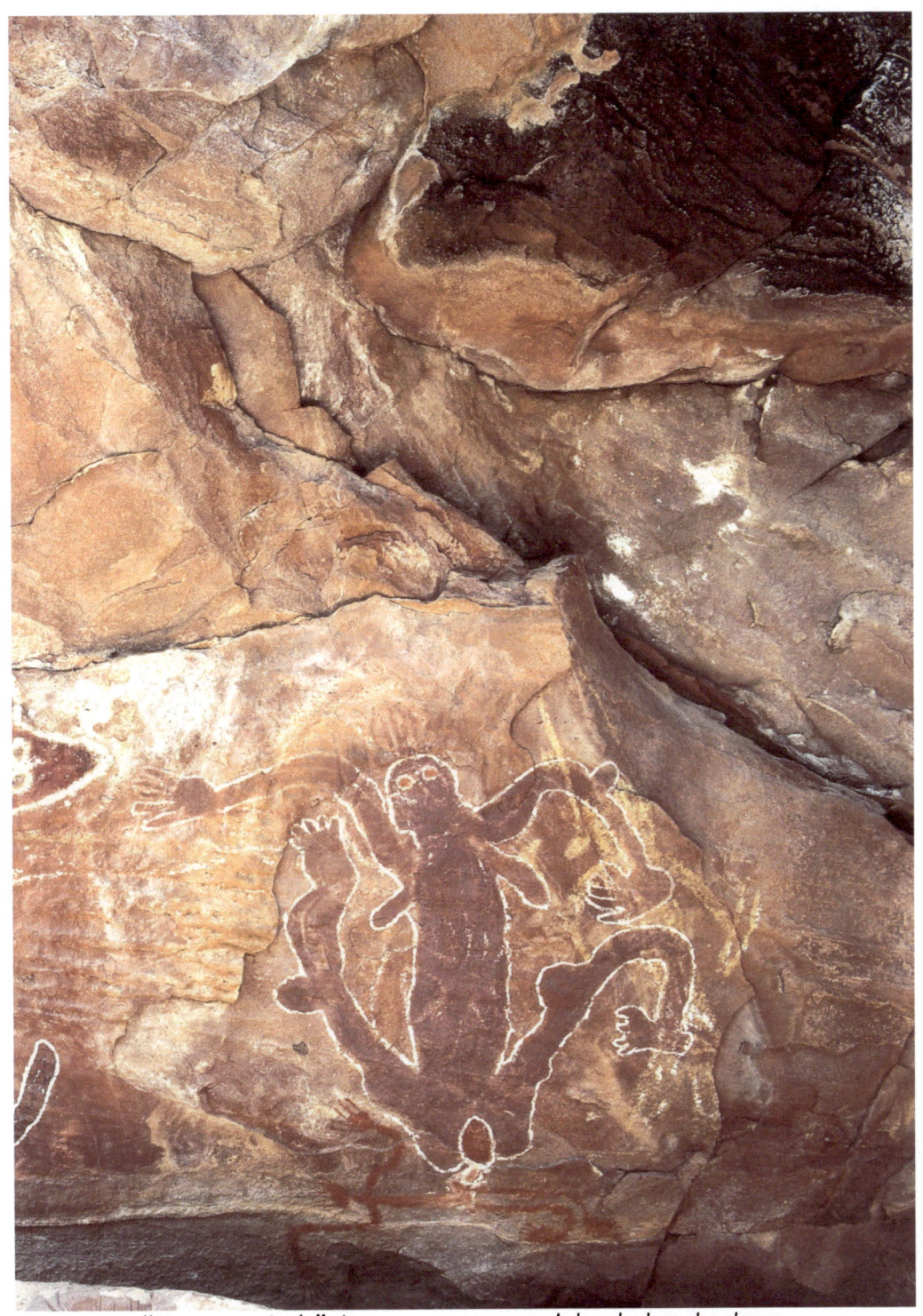
*"Maravanna Lady" sits on a young woman's head when she sleeps.*

## Fertility Place
*Wardaman Tribe, Northern Territory*

The Wardaman people have women's, men's, and *normal* rock art sites. The women's and men's sites may only be visited by people of the same gender, whereas normal sites may be visited by anyone. This is a large *normal* site with a married man and woman above a petroglyph-covered shelf. ▽

The shelf's purple/blue color comes from pigment that mixed as it washed-down over the millennia after repeated repainting of the images above. It's a strikingly picturesque place with sandstone sloping forward, providing a shallow shaded shelter. Trees cling to the cracks as their roots stretch to the ground. ▷

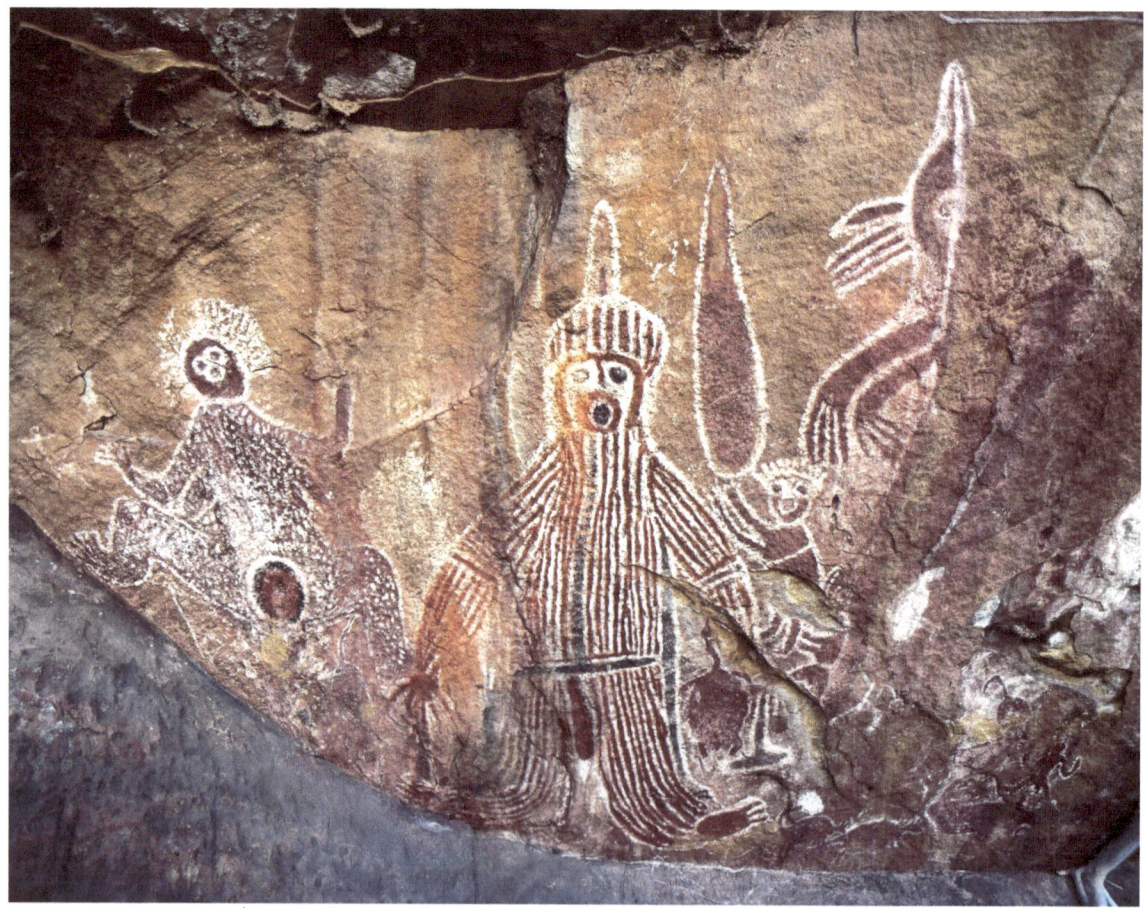

*(detail of page 39) This is a normal site that anyone may visit.*

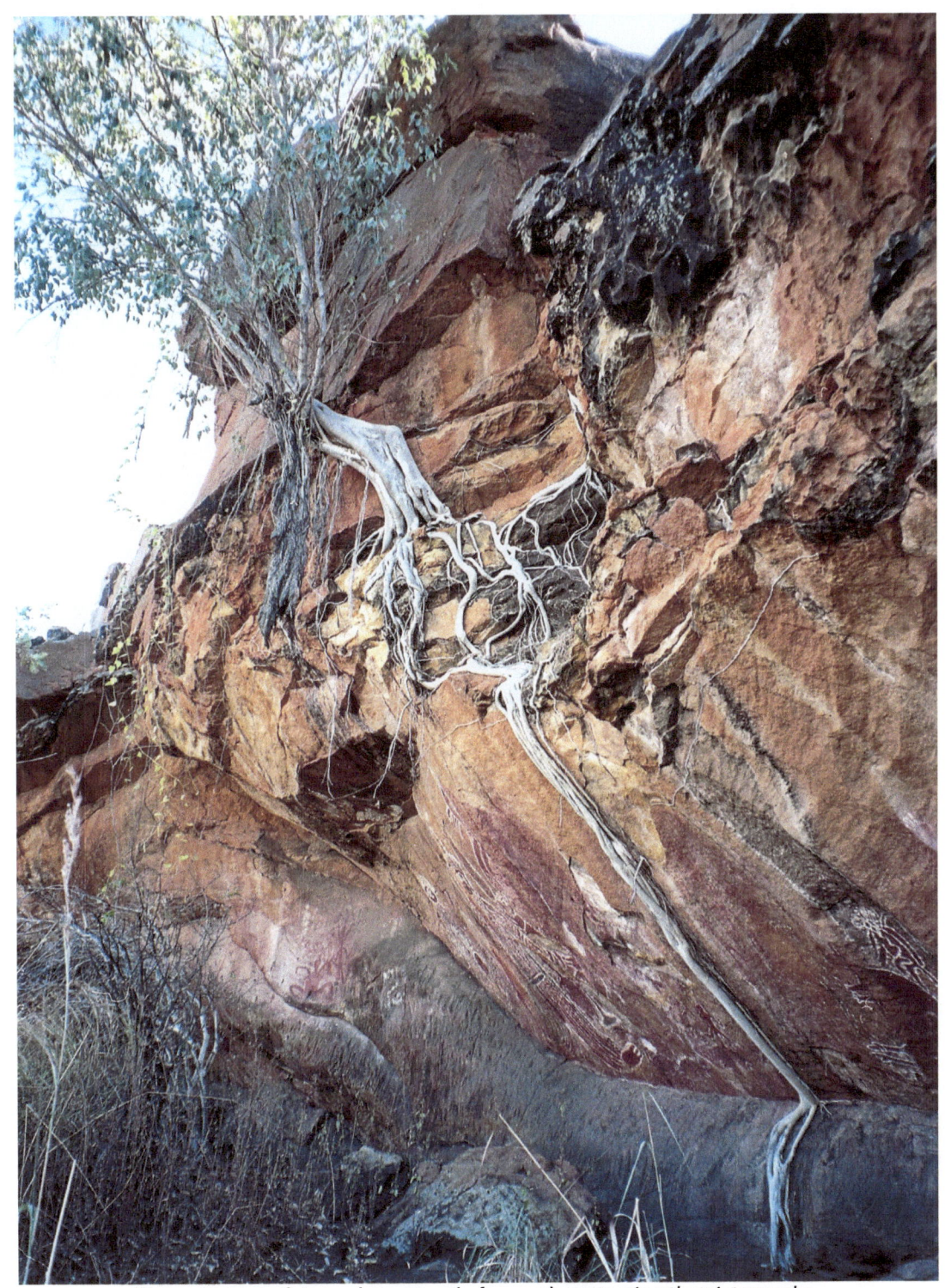
*The orange sandstone slopes gently forward, protecting the pictographs.*

## Old Devil Lady
*Wardaman Tribe, Northern Territory*

The white female is the *Old Devil Lady*—she's a good devil—who cares for people when they're sick and "takes the spirits away when they die." Later, she redistributes them to living men or women, who have their own children with these spirits—often with the birthmark of their predecessor. Here, she is pulling a spirit "up to the top." It's attached to her bottom by a thin stretched string. ▽

The site is old and densely layered, continuously repainted over many generations. Faint forms in red, orange and yellow fill the background—some are striped—and the eyes are outlined in white. Those with eyes but no mouths refer to an early phase of the creation when people had not yet begun to talk. The faintest are the oldest. Some scholars suggest that Australian rock art may date back as far as 40,000 years.

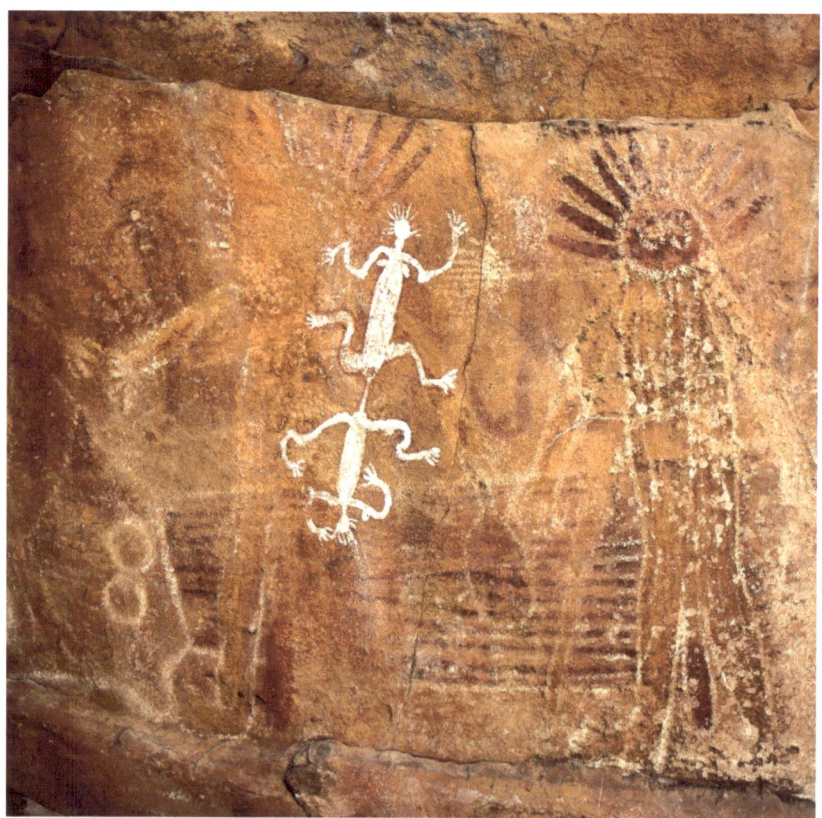

*The white female (upper figure) is the "Old Devil Lady."*

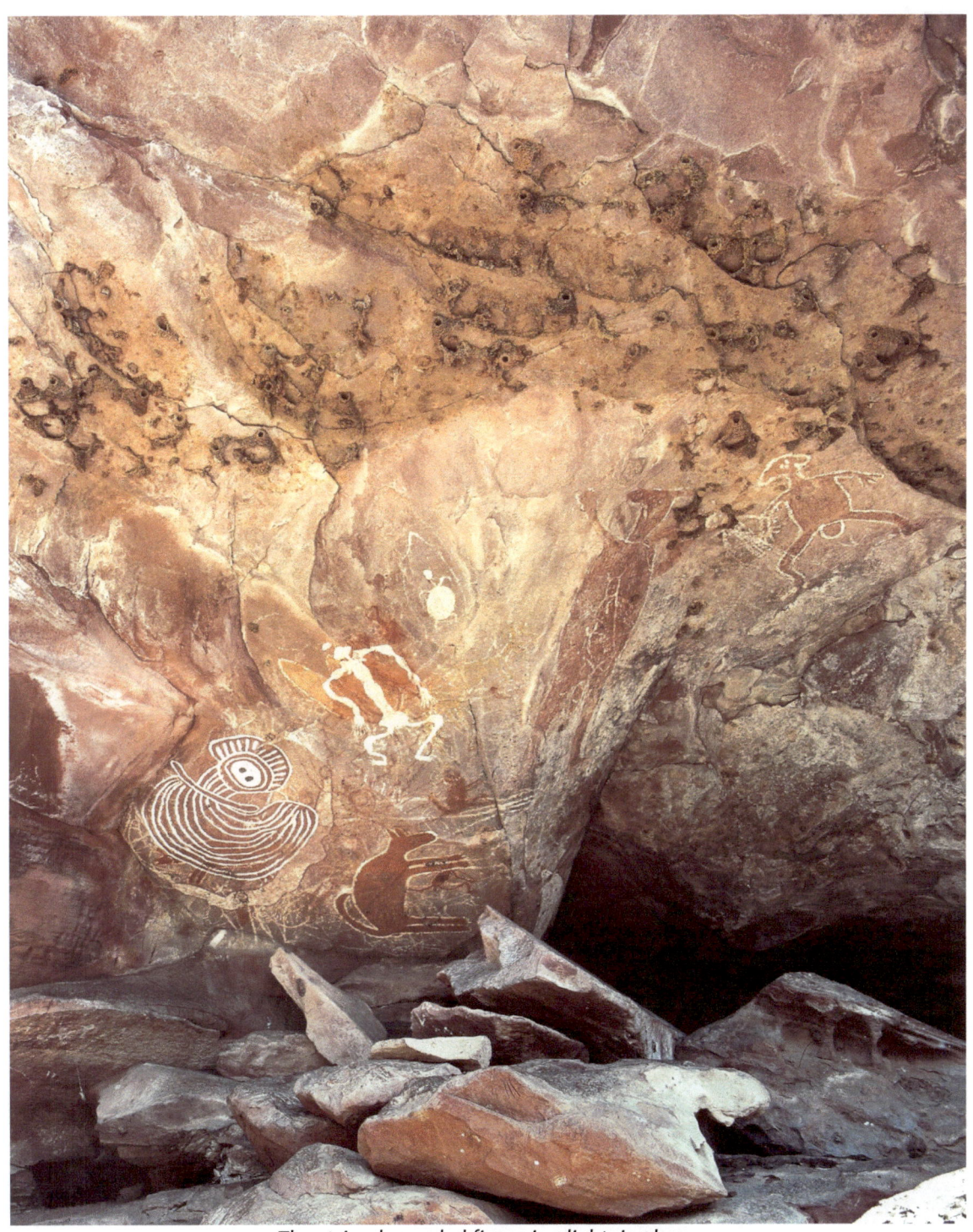
*The striped rounded figure is a lightning boy.*

## *Red Kangaroos*
*Wardaman Tribe, Northern Territory*

Red desert kangaroos play prominently in the Wardaman creation story. That's the time when trees could walk and animals could talk. Kangaroos ran out across the desert in packs chased by dogs. Yidumduma said the red ones were "running flat out" toward Adelaide while brown ones raced toward Cape York and gray ones ran toward Sydney. Two red kangaroos split off from the pack and are imprinted on the rocks, where we can still see them today. ▷

The small white animals clustered on the right of this scene are min-mins. They are mythical dog-like creatures who appear at night as balls of light, racing along the horizon. Yidumduma said, "you can drive a car 150-k's and the min-mins keep right up." The large red animal is a wallaroo, sheltering two young humans under her belly. ▽

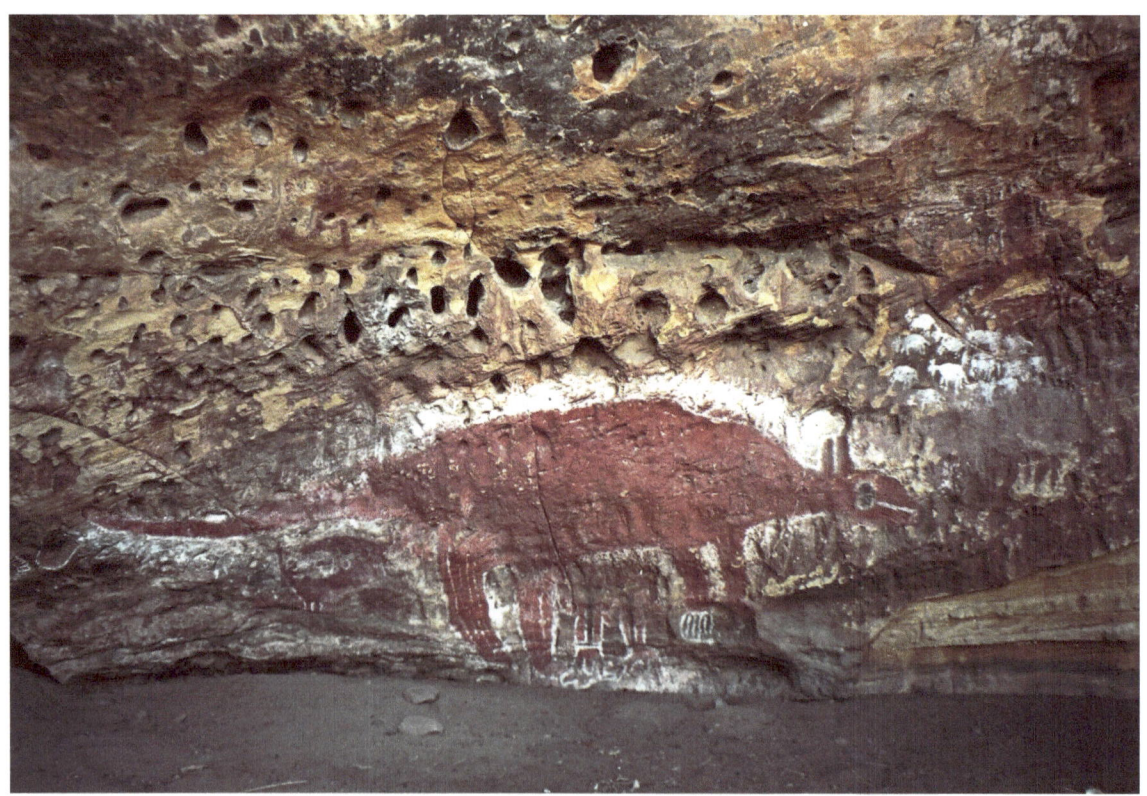

*Mythical min-mins cluster above the head of a red wallaroo.*

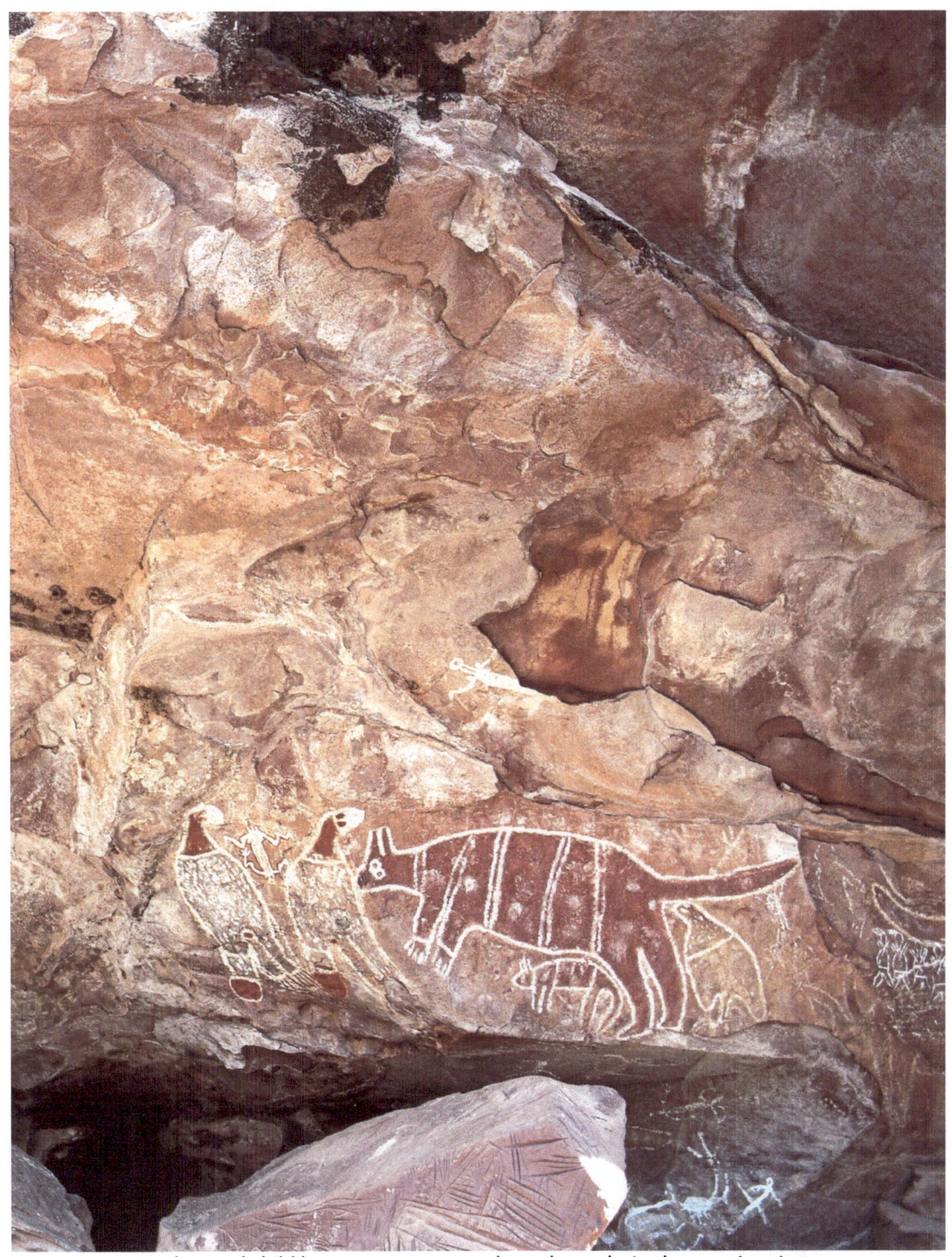
*Mother and child kangaroos were stuck on the rocks in the creation time.*

### Red Barracuda
*Wardaman Tribe, Northern Territory*

A red barracuda is on the back wall of this shallow sandstone shelter. It's outlined in white, in the characteristic Wardaman style with a hint of x-ray revealing the spine. Emu and wallaroo legs protrude from the mass of red on the sloping ceiling and a small lightning person stands below. ▽

I'm not sure what kind of fish this is—swimming upward, trailed by a minnow. Yidumduma didn't mention it as we passed by, but it appears to be old—and painted by a master! ▷

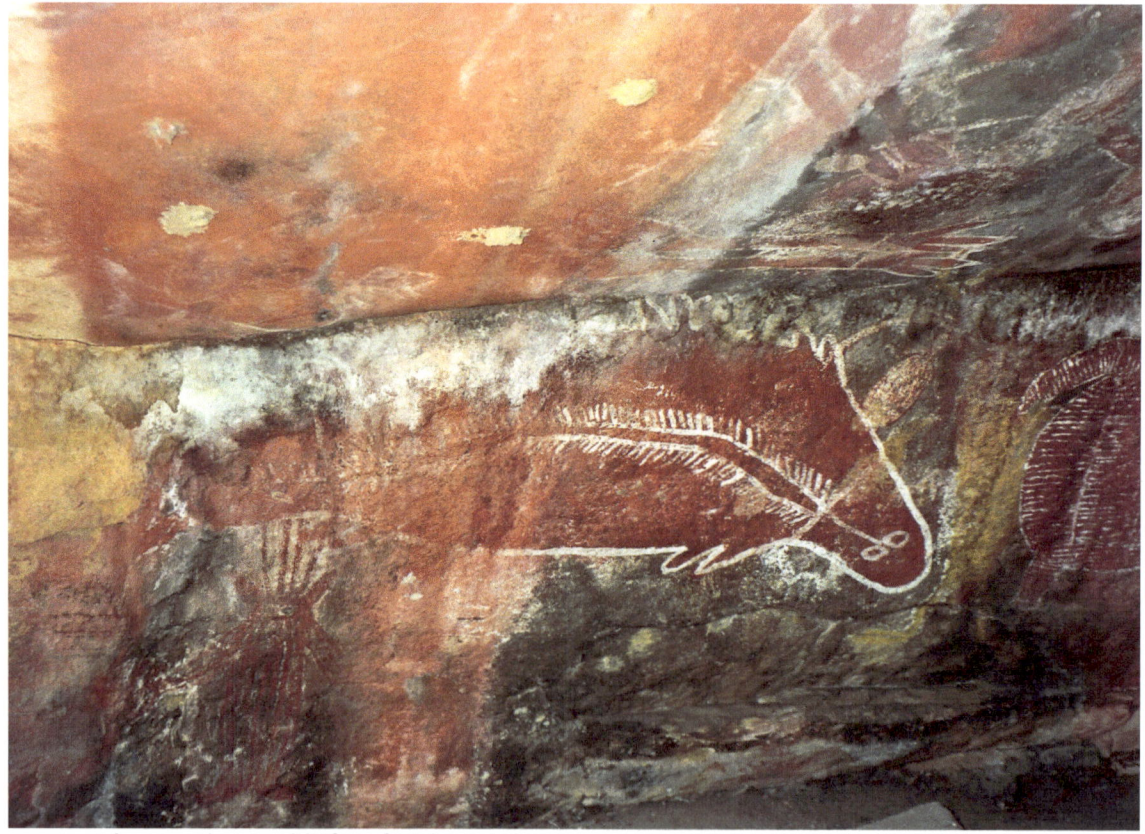

*A barracuda, roughly four-feet long, is centered on the back wall of this shallow shelter.*

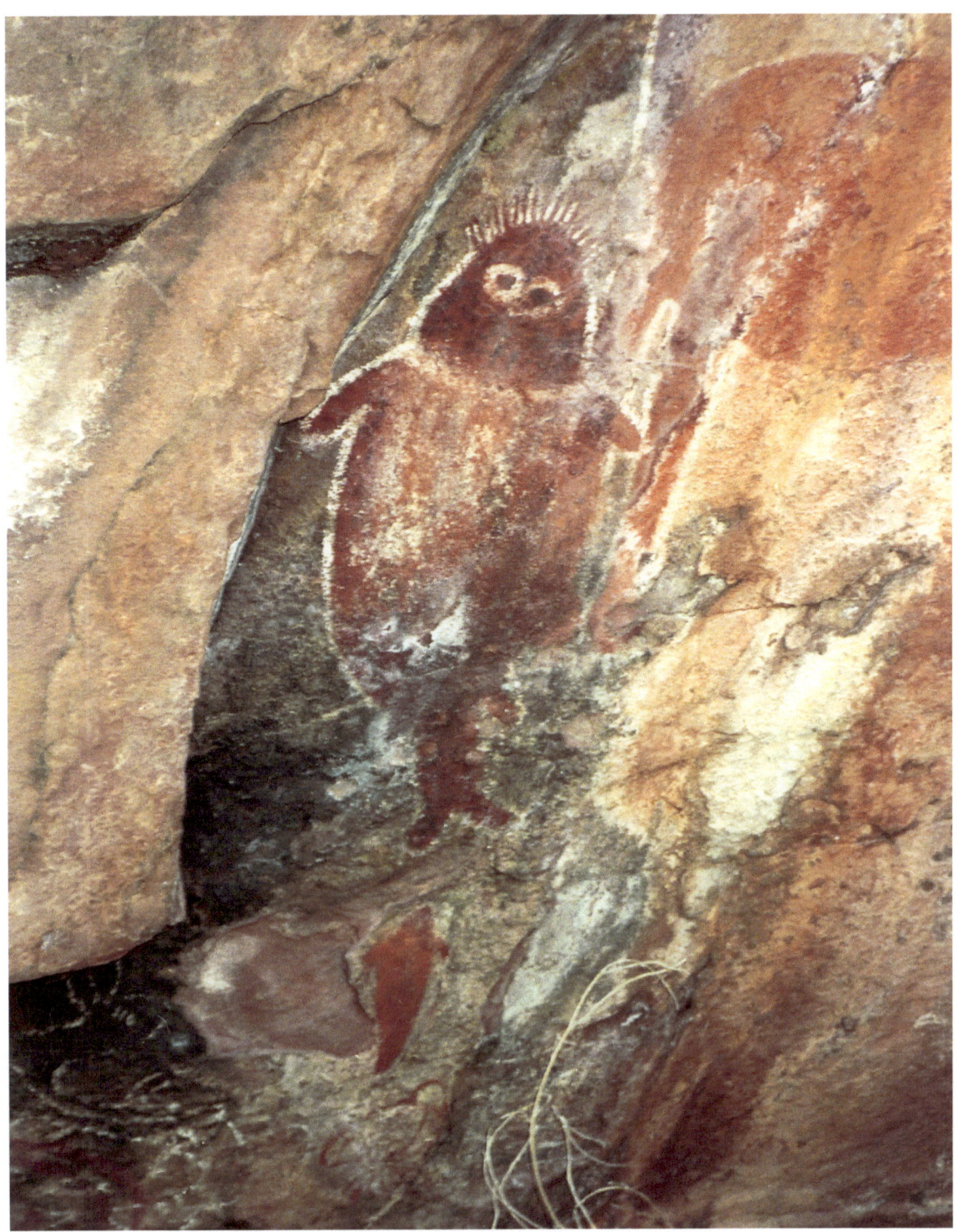
*An unknown fish swims upward, trailed by a minnow.*

## *Rainbow Serpent*
*Wardaman Tribe, Northern Territory*

During the creation, the *Rainbow Serpent* (*lower right*) "made this great big spiritual song and made the water rise up, flooding the whole world with saltwater from the sea, all the way to the mountaintops. But the grey and brown chicken hawks cut off the serpent's head with sharp spears, killing him, making the water flow back. Then, the blackhead and water pythons carved out all the rivers, and the rainbow people made it rain, so everyone could drink." (Yidumduma's approximate quote) ▷

This is the *Serpent's* severed head (*upper right*), now hardened into rock. When the land was flooded, everything was soft like mud. ▷

The Wardaman artists collect mineral pigments from particular places and store them until it's time to paint. Then, they grind them into fine powder on these boulders. The red is hematite (iron-rich rock). When it's time to paint, they mix the pigment with a plant sap and apply it like a water-based paint. Some is absorbed and some builds up on the surface. The shiny finish seen at some sites is tree sap varnish that was applied on top of the paint to form a protective coating. They use the same mineral pigments on their bodies for ceremonies. ▽

*The artists grind mineral pigments on these boulders.*

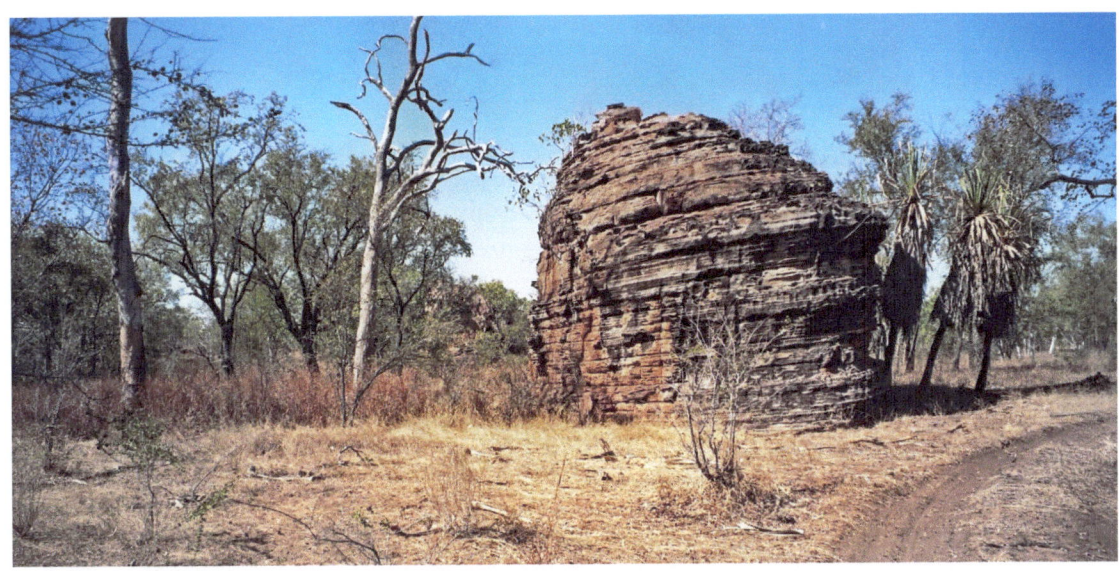

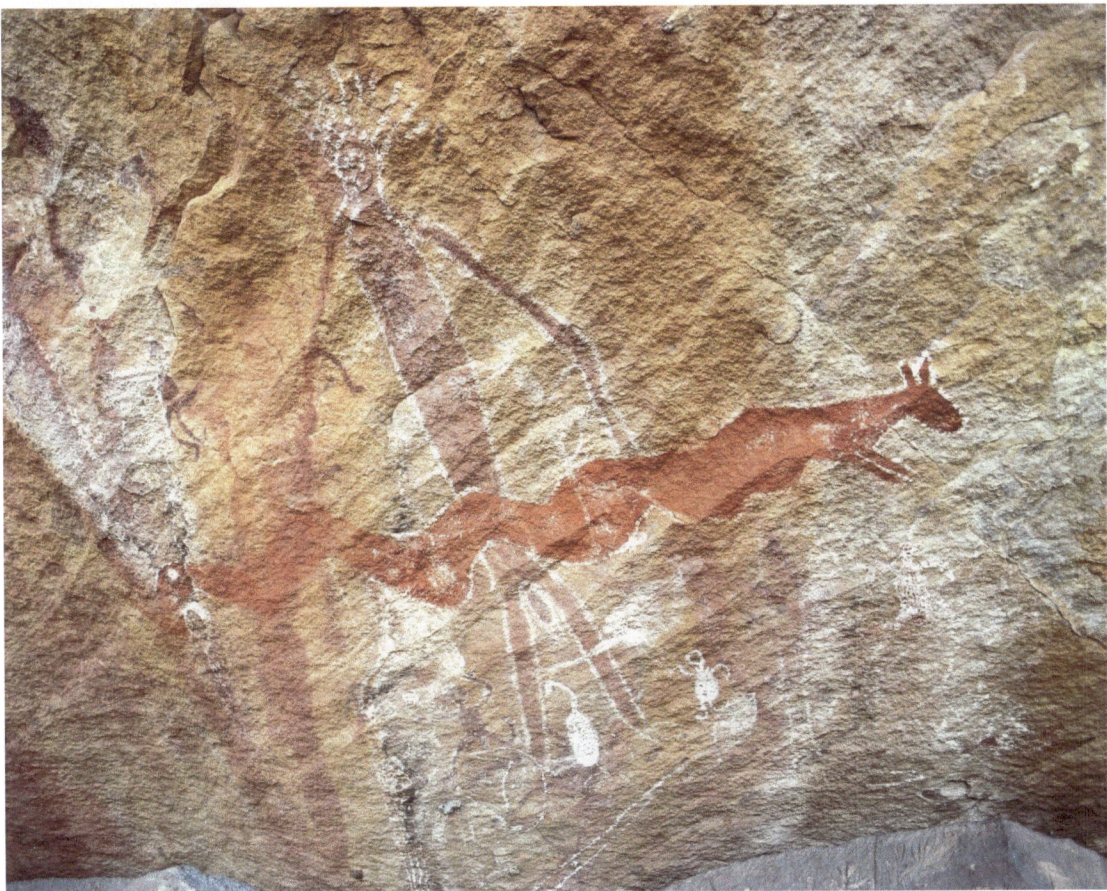

*(upper) The "Rainbow Serpent's" severed head turned into rock, and is still there today.
(lower) The serpent "made this great big spiritual song and made the water rise up."*

## *Serpent Person*
*Victoria River, Northern Territory*

Aboriginal clans tell individualized creation stories, invariably including a great serpent. *(lower right)* The *Serpent Person* pictured here is 14.5 feet long and 4 feet wide. At first glance, it appears to be a reclining regular person, but closer inspection reveals a serpent's tail where the legs should be. It's hard to determine the gender, but it may be female, considering the round red circle in the pelvic area. ▷

Its tiny hands emphasize the scale of its broad body–and its mesmerizing white-outlined eyes seemed to follow our every move. Its high placement on the cliffs above the Victoria River offers the perfect vantage to observe the wide valley below. ▽

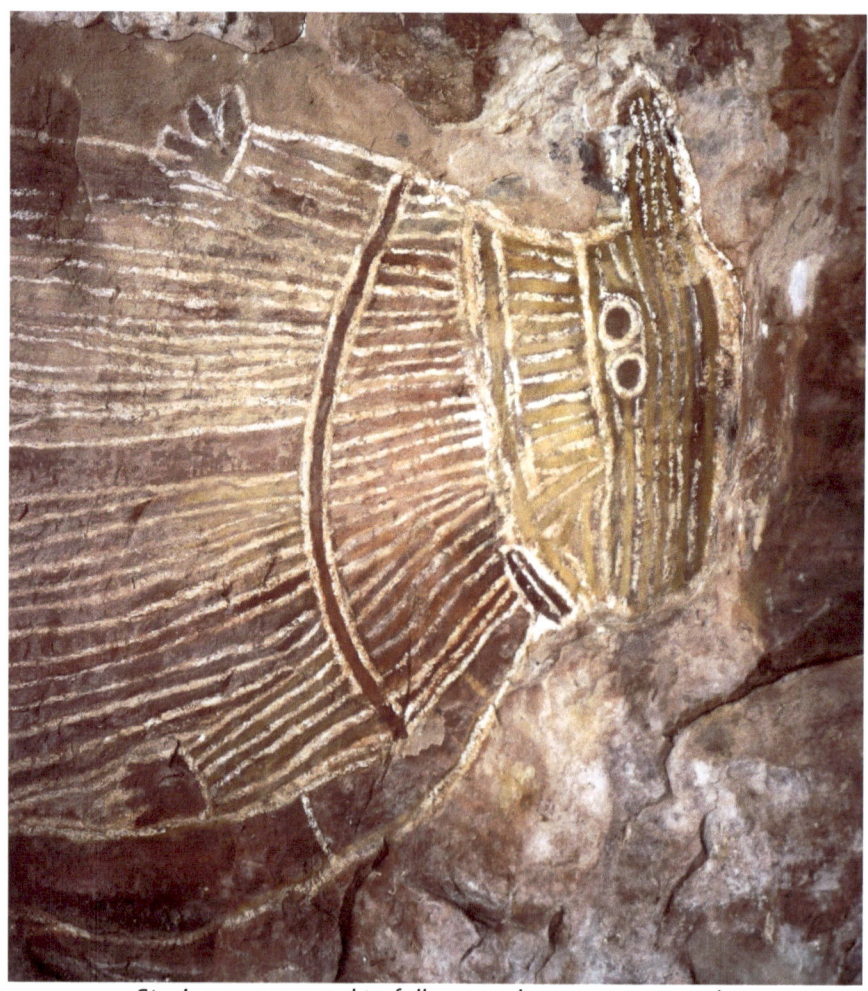

*Staring eyes seemed to follow us wherever we moved.*

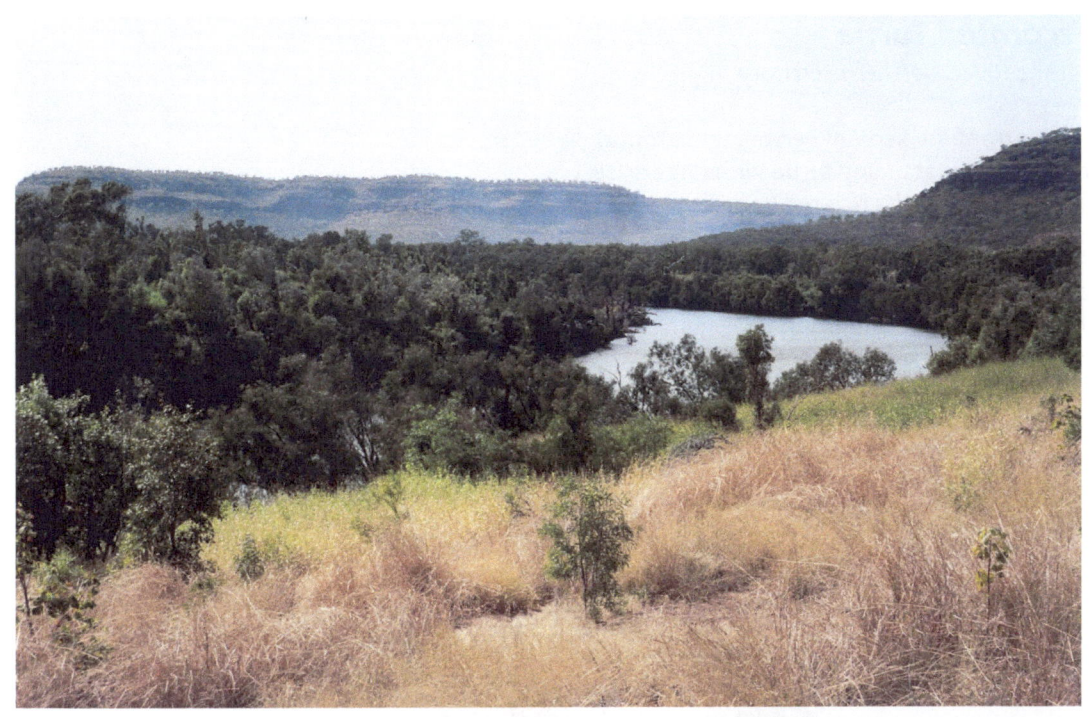
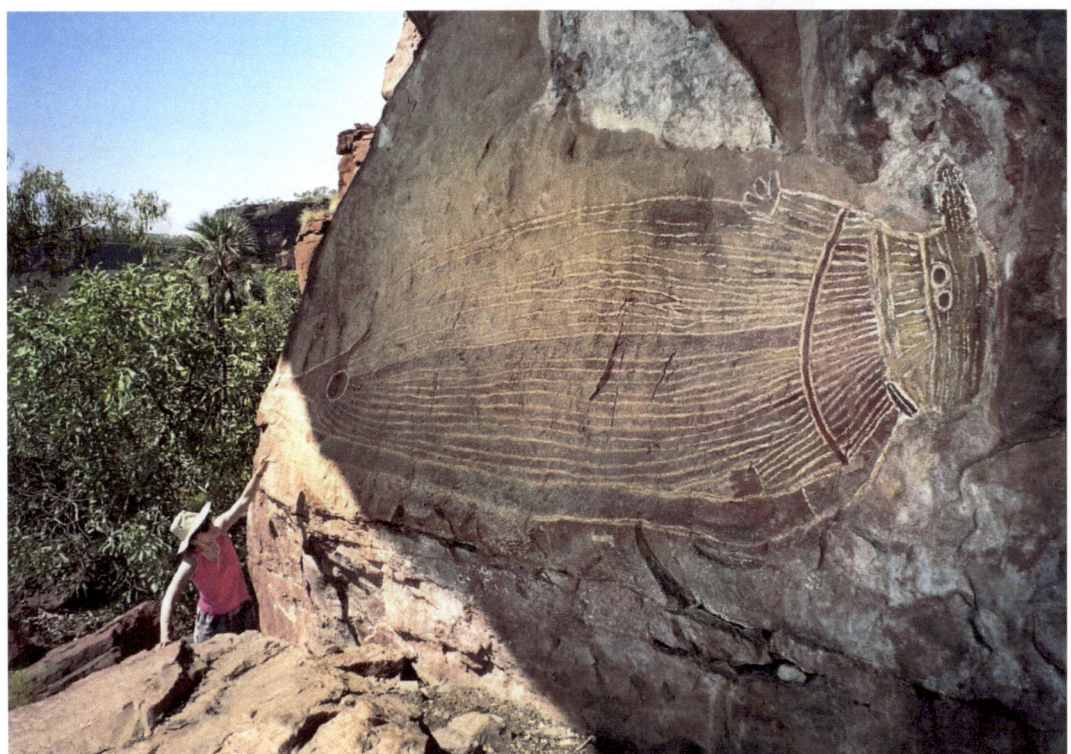
*The "Serpent Person" overlooks a broad bend in the emerald-banked Victoria River.*

## *Decorated Turtle*
*Victoria River, Northern Territory*

Not far from the *Serpent Person*, Erma found this enigmatic standing turtle with finger-size dots surrounding its rich red body. ▷

I take my time photographing, so she is usually up ahead, looking for other things. This time I heard a shriek in the distance when Erma peered into a crack and saw two eyes staring back! She said it was a snake but I told her it was probably a lizard trying to keep cool–but we'll never know for sure.

*The "Decorated Turtle" setting.*

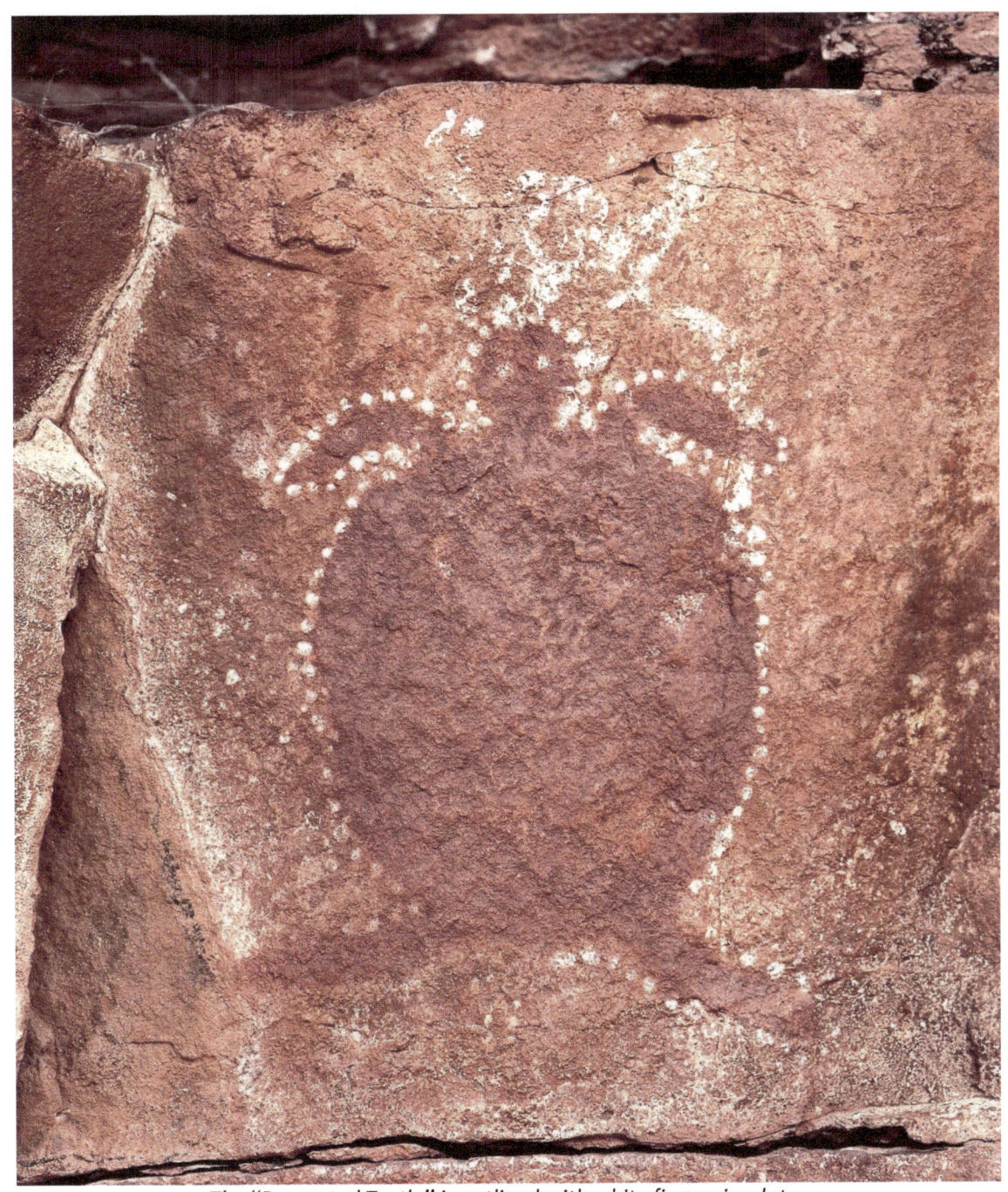
*The "Decorated Turtle" is outlined with white finger-size dots.*

## Road to Arnhem Land
*Northern Territory*

Arnhem Land is a tropical wetland in the northeastern corner of the Northern Territory, bordered by the Arafura Sea and the Gulf of Carpentaria on the north and east, and Kakadu National Park on the west. Its sparse population is predominantly Aboriginal.

Erma and I drove to Kakadu National Park in a worn out Land Rover we rented in Darwin. Along the way, we forded streams and stopped at termite mounds, adjusting to the unfamiliar terrain. We discovered that the large mounds have fins for cooling, and are oval-shaped, the narrowest edge pointing north toward the sun. This keeps its wider sides shaded during the hottest part of the day.

*At each creek we climbed out to check the water before fording through.*

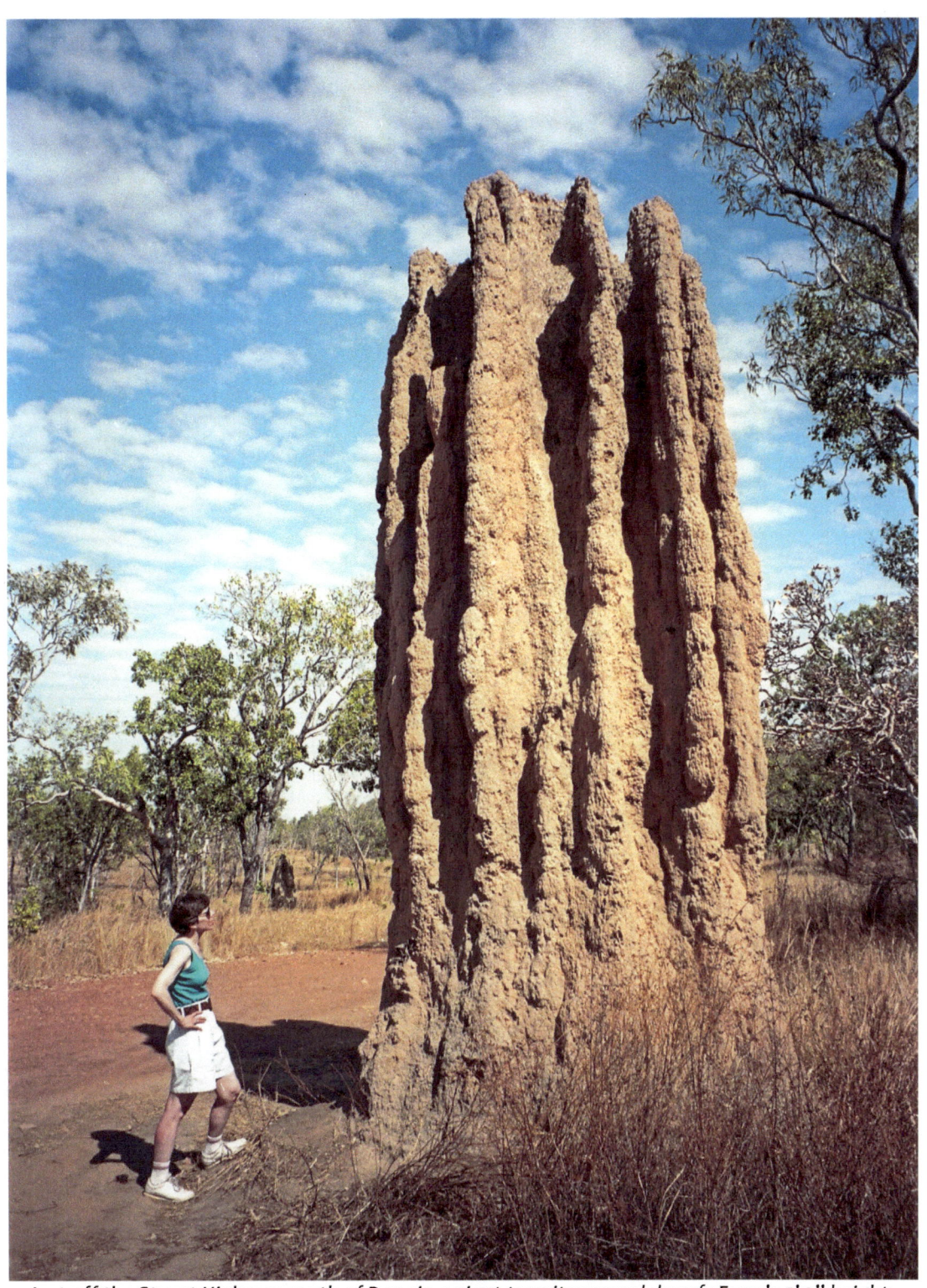
*Just off the Stuart Highway south of Darwin a giant termite mound dwarfs Erma's 5' 2" height.*

## Thin Fisherman
*Ubirr, Kakadu National Park*

It took a skilled artist to draw this diagrammatic fisherman so precisely, using saturated red on the multi-toned rock. Mabuyu carries barbed spears in his left hand and a spear-thrower to launch them in his right. He also carries a goose-wing fan in the hand with the spears, and drapes a lightly sketched dilly bag from his neck. An X marks his pelvis (clothing?) and his prominent male organ (and more clothing?) hang below. Intriguingly, Mabuyu's feathered head is drawn in profile while the rest of his body is frontal. ▷▷

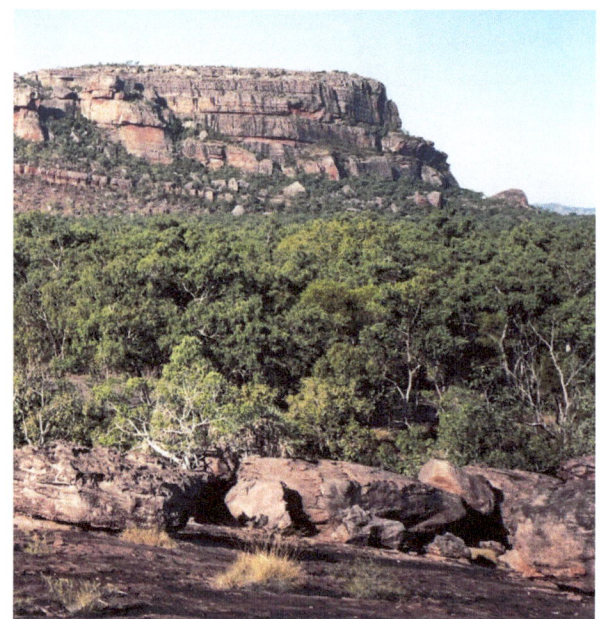

*In the distance, Nourlangie Rock juts out from the sandstone escarpment.*

*We camped near at the Djarradjin Billabong, always alert for crocodiles.*

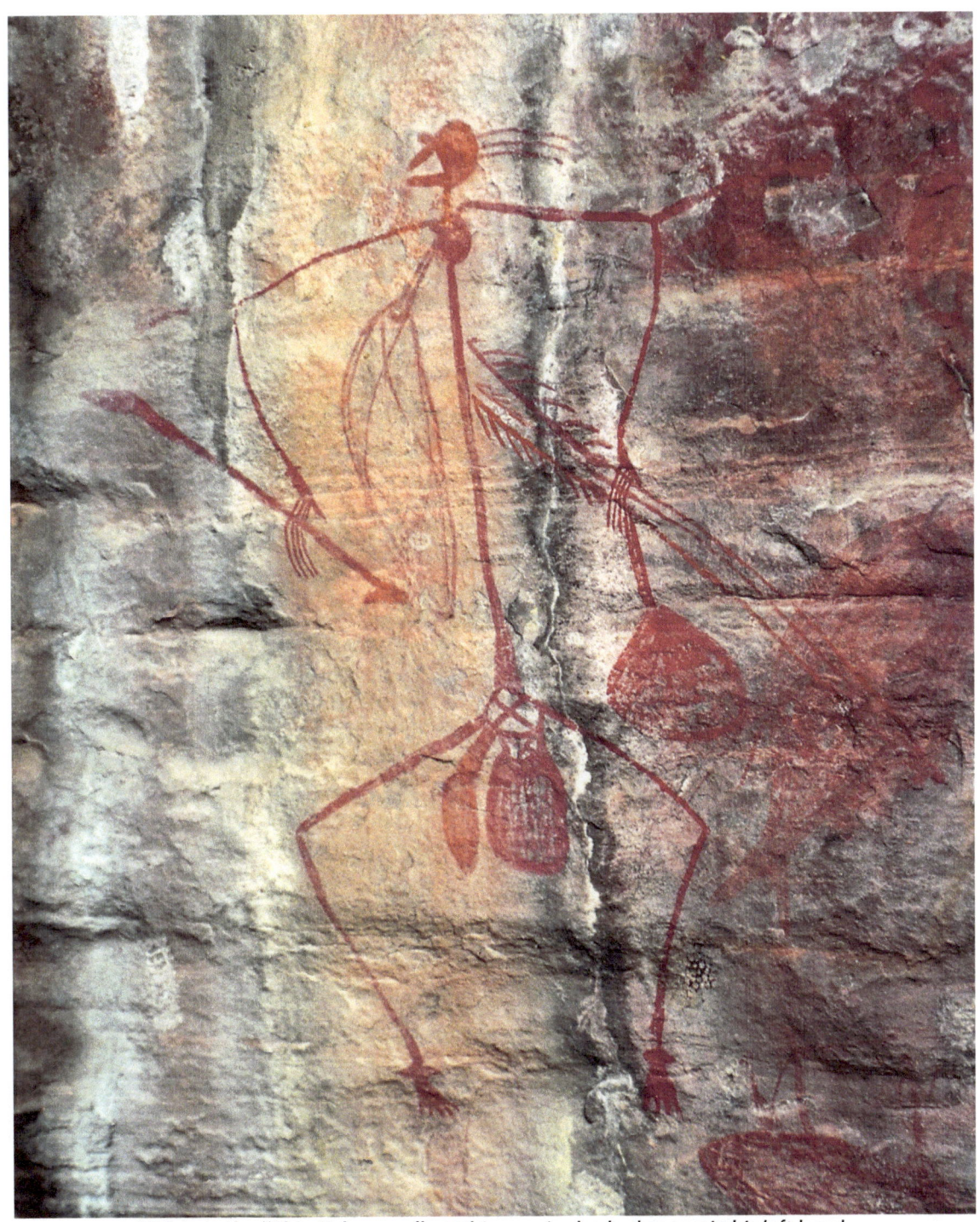
*Mabuyu, the "Thin Fisherman" at Ubirr carries barbed spears in his left hand and a spear-thrower to launch them in his right.*

## Many Fish
*Ubirr, Kakadu National Park*

Fish (djenj) were valued by Aboriginal people, especially by those living near the coast. In Ubirr, we saw numerous examples in the rock art, exactingly drawn in the complex x-ray style. This style depicts both the inside and the outside simultaneously, allowing for precise identification. The barramundi (with its up-turned nose) is an intriguing fish, beginning life as a male and later changing to female (Chaloupka, 1993).

This skillfully composed frieze is high in Ubirr's main shelter. A row of fish, mostly barramundi, and a tortoise (who swallowed a snake?) are exactingly laid-out on the smooth rock surface. Positive and negative handprints mark the left and a small white European man with his hands in his pockets and wearing a hat (a later addition) is on the right. The composition is at once beautiful and complex—both naturalistic and abstract. Aboriginals memorialized game animals and fish such as these to insure regeneration for the future. The large barramundi are some 4-feet long. ▽

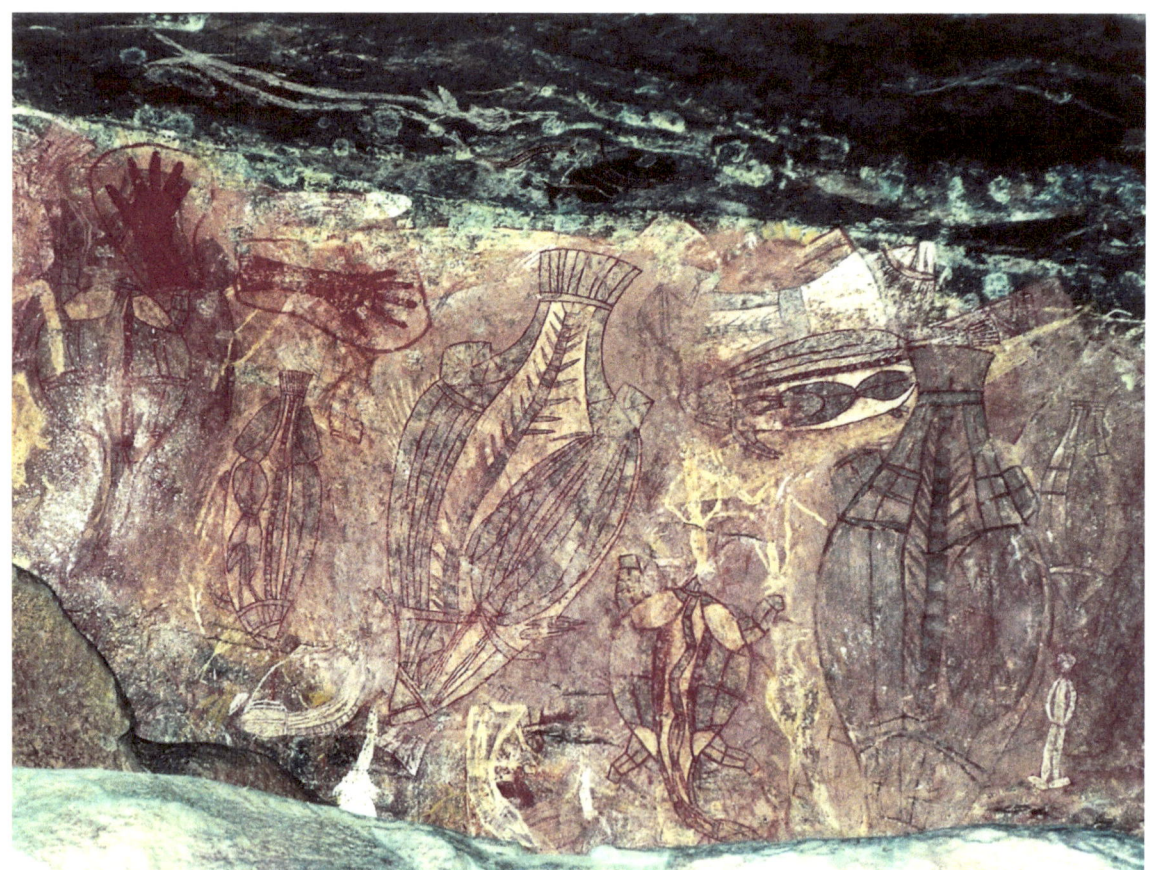

*X-ray style fish, mostly barramundi, and a tortoise are exactly positioned on the smooth surface.*

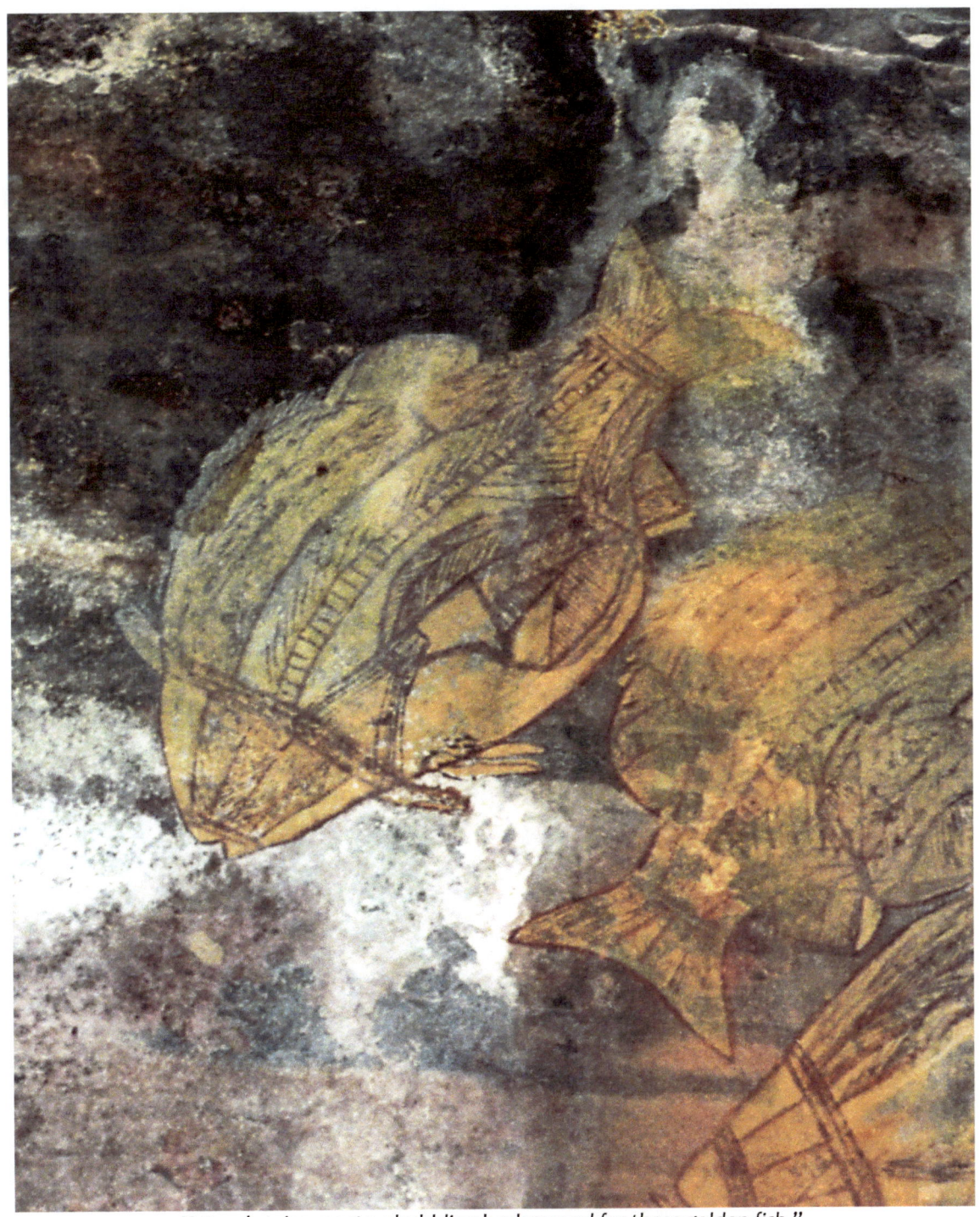

*Natural stains create a bubbling background for these golden fish," seemingly swimming through watery rapids.*

## Tall People
*Nanguluwur, Kakadu National Park*

Accomplished artists applied these elongated figures to the blue-gray rocks of Naguluwur. Painted in yellow and outlined in red, a reclining woman features all-over body decoration, including dots down her torso and cross-hatching on her skin. For unknown reasons, long protrusions extend from her foot, head, breasts and shoulder. ▽

A lanky man in white paint flashes propeller-like fingers—six to each hand—for an agitated effect. There is little decoration on his body but his form is expressively contoured, disproportionately tall, slightly leaning. He appears to be emerging from a darkened doorway, framed by the fractured rocks. I felt as though I were seeing El Greco working in another lifetime! ▷

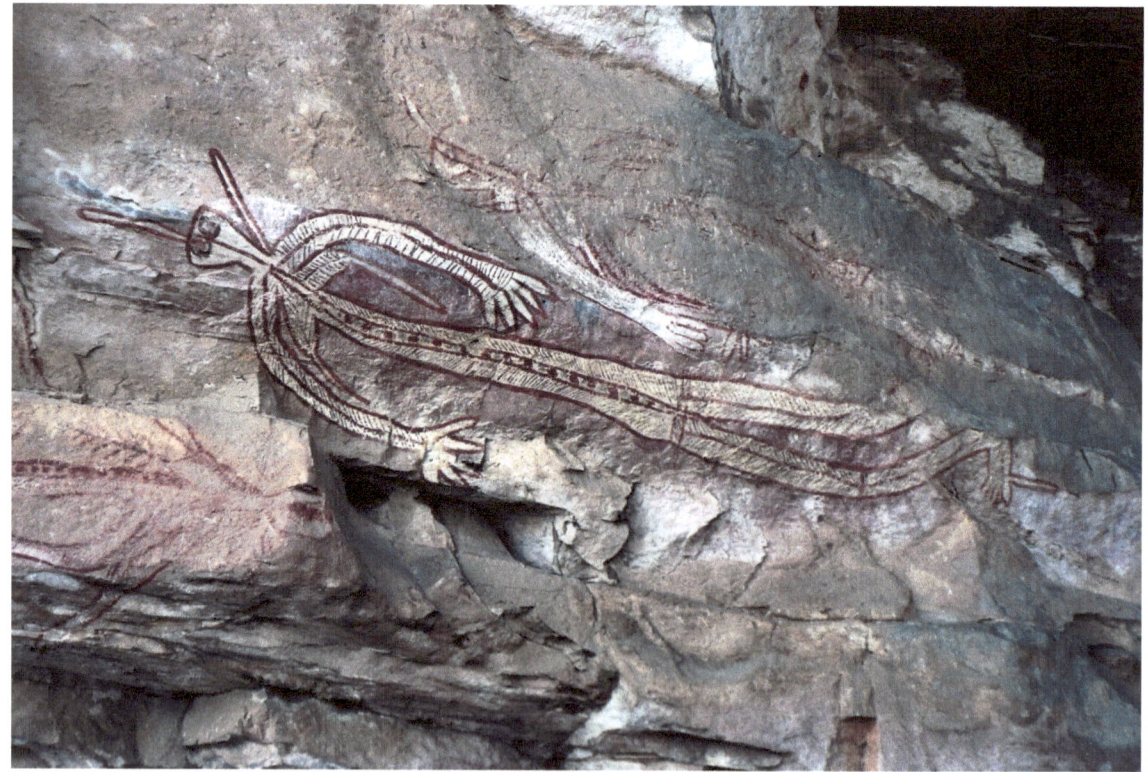

*A reclining woman features all-over body decoration.*

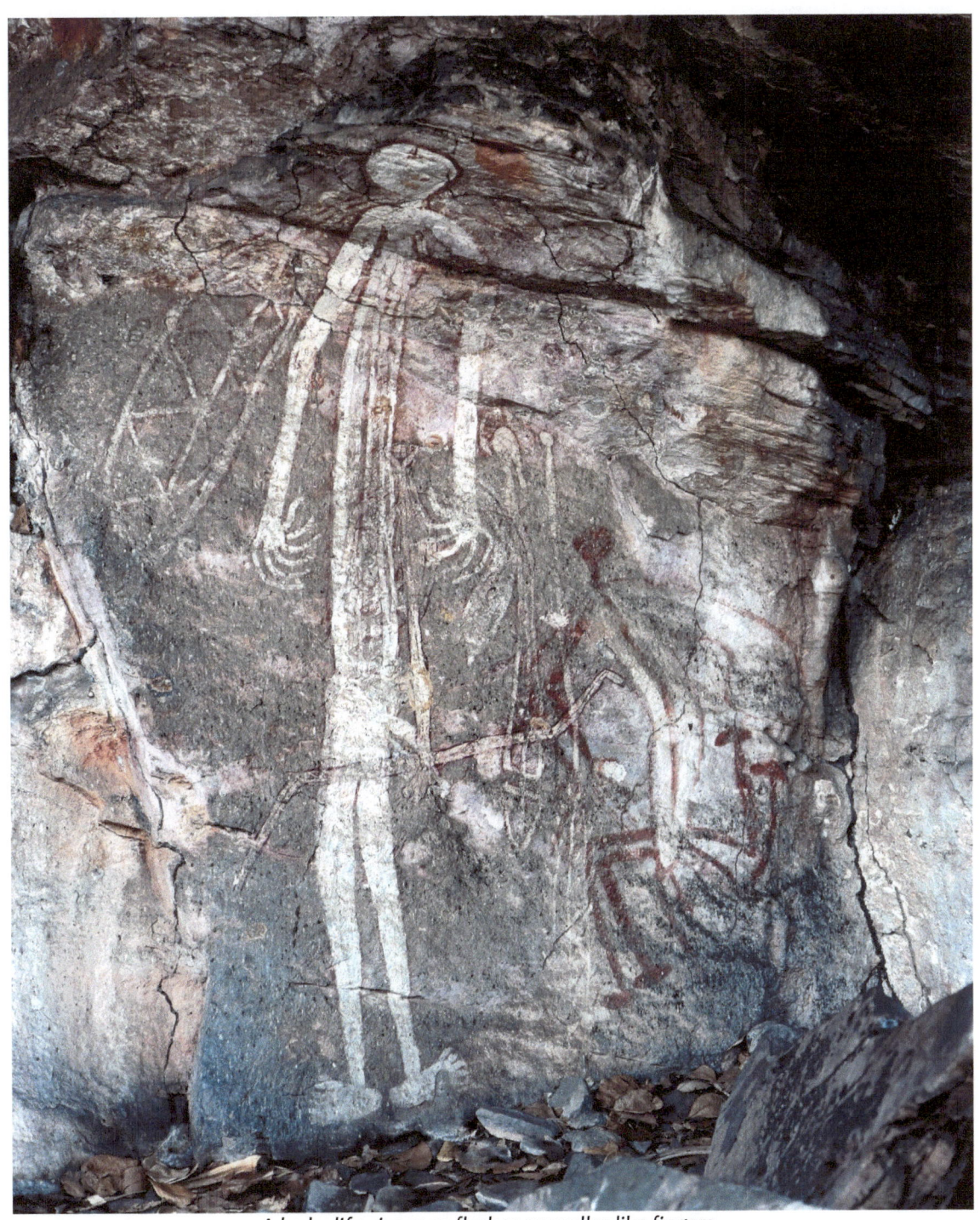
*A lanky life-size man flashes propeller-like fingers.*

## Crooked Woman
*Nourlangie Rock, Kakadu National Park*

In this section of a large all-over composition at Nourlangie Rock, a skeletal lightning man, a white crocodile and other figures in red, yellow, orange and white, surround a ladder-bodied, crooked-limbed woman. It's a packed painting, visually active, in dense color. In my eye, it's comparable to famous New York School paintings of the 1950s. ▷

I try to turn around from time to time when I'm photographing rock art because that view can be unexpectedly impressive. Here the long roots of a predator tree envelop a towering boab, both competing for the same sky space. ▽

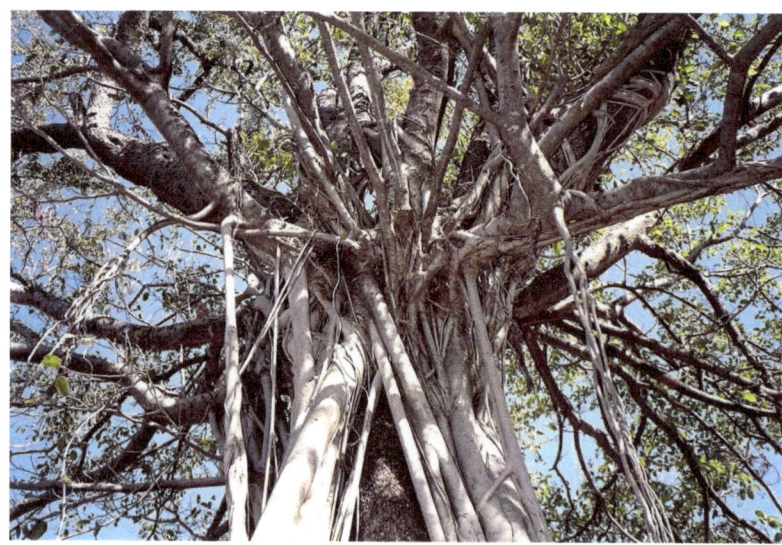

*A predator's roots wrap a towering boab, competing for the sky.*

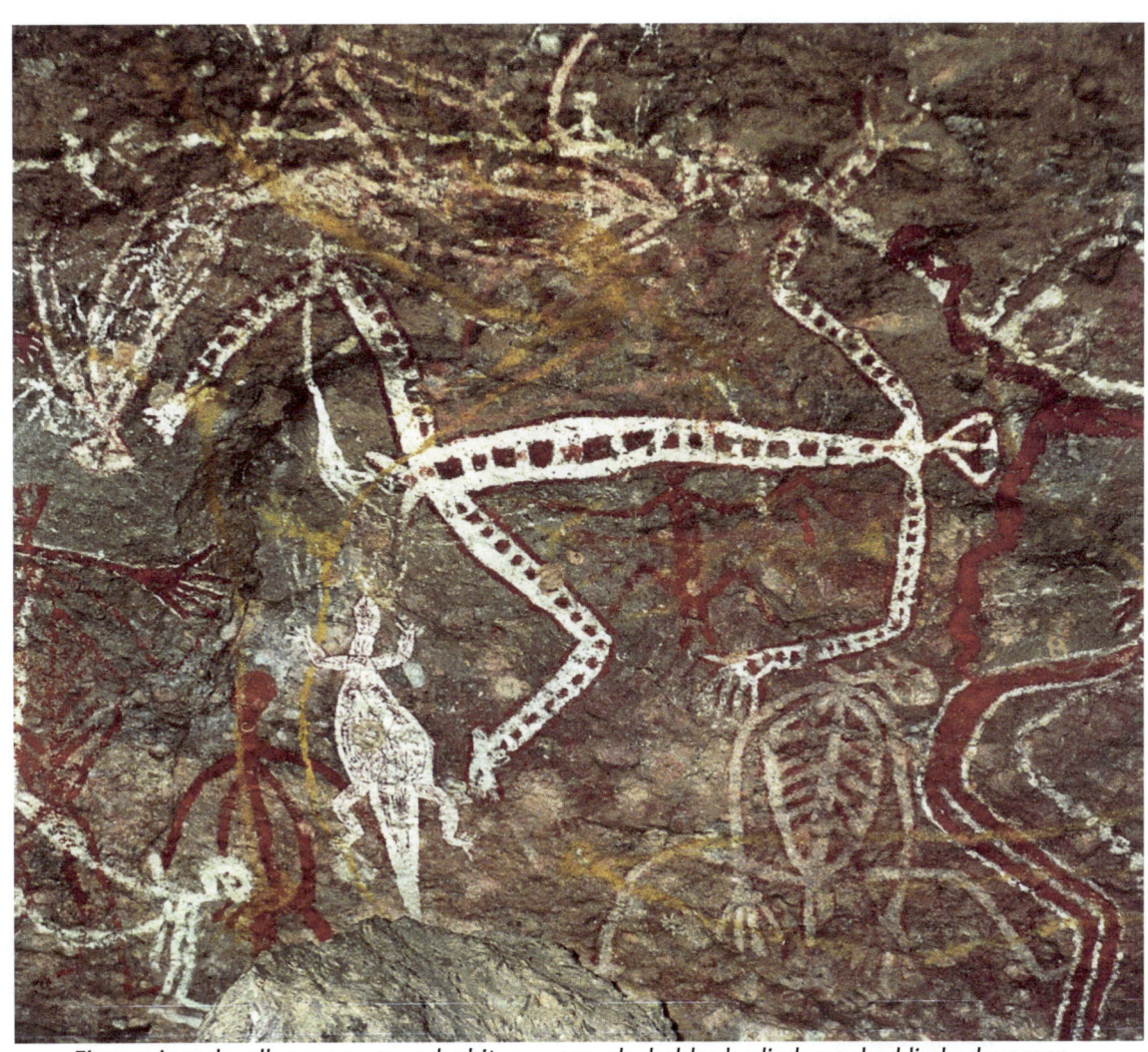
*Figures in red, yellow, orange and white, surround a ladder-bodied, crooked-limbed woman.*

## Procession

*Anbangbang shelter, Nourlangie Rock, Kakadu National Park*

Here are two overlapping sections of a large mural at Nourlangie. In 1964, Nayombolmi and his two friends Djimongurr and Djorlom painted these and several other panels in the area to memorialize some of their tribes' stories. Nayombolmi painted the stylized figures in the lower half of the composition and Djimongurr and Djorlom made the traditional images above. Nayombolmi was a virtuoso painter, whose x-ray style work is exceptionally well drawn and easily recognizable. He also painted *The Woman Eater (page 65)*.

A lightning man *(white circular figure in the upper right)* and his wife *(lower center)* hover over a procession of stylized men and women. The large frog-like creature *(upper center)* is Namandjolg, who had incest with his sister and was turned into a crocodile. ▽

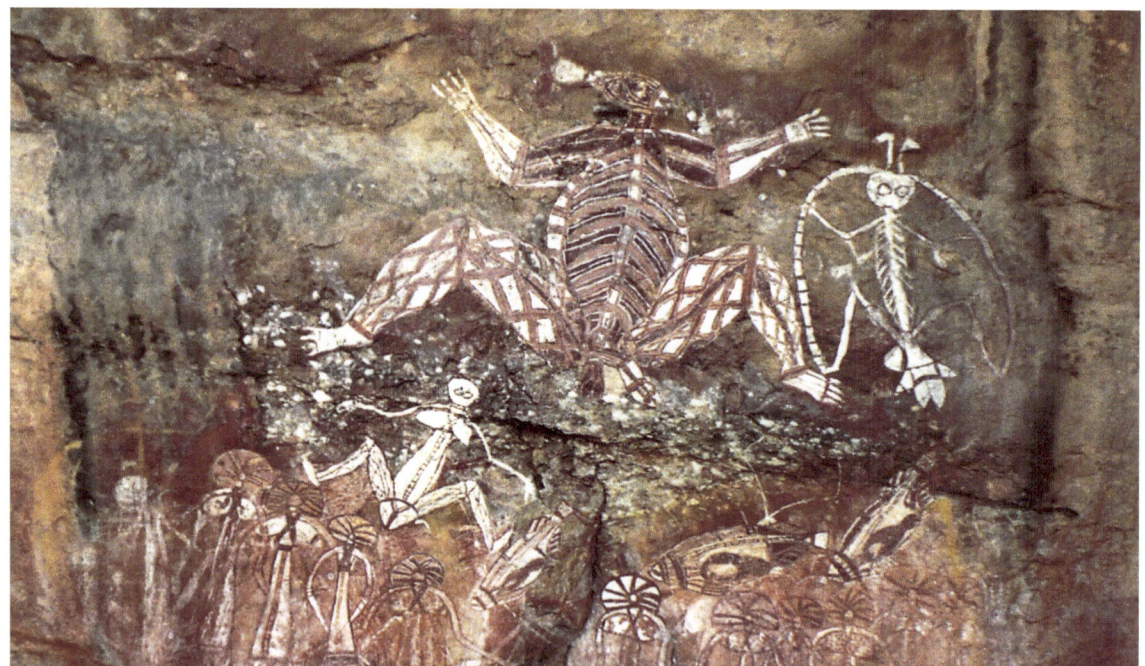

*A lightning man (white circular figure in the upper right) and his wife (lower center) hover over stylized men and women. The large frog-like creature (upper center) broke tribal laws.*

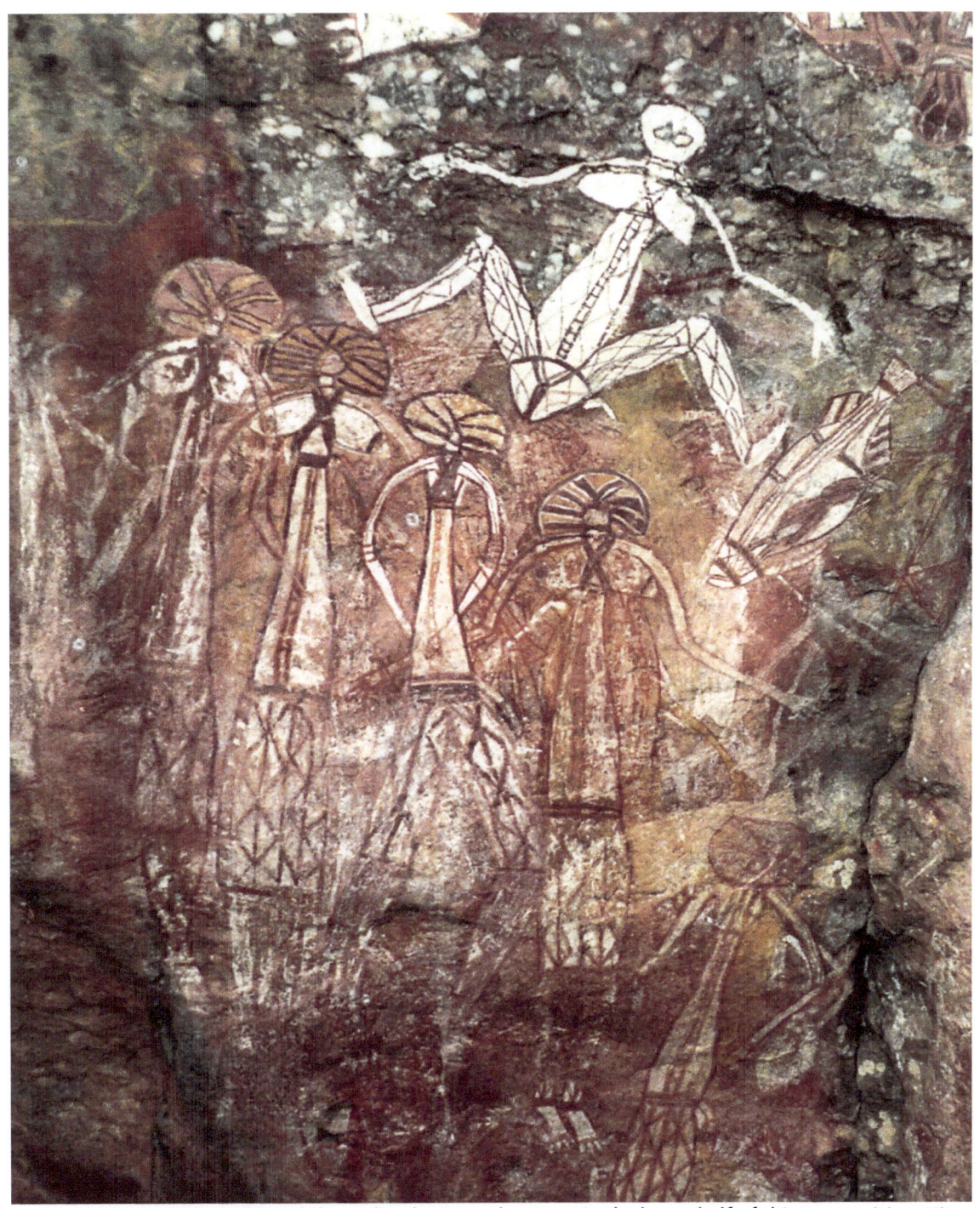

*In 1964, Nayombolmi, painted the stylized men and women in the lower half of this composition. His two friends Djimongurr and Djorlom made the traditional images above.*

## *The Woman Eater*
*Anbangbang shelter, Nourlangie Rock, Kakadu National Park*

Nabulwinjbulwinj is a dangerous spirit who kills and then eats women who disobey the tribal laws. The famous artist, Nayombolmi painted this x-ray style version in 1964. ▷

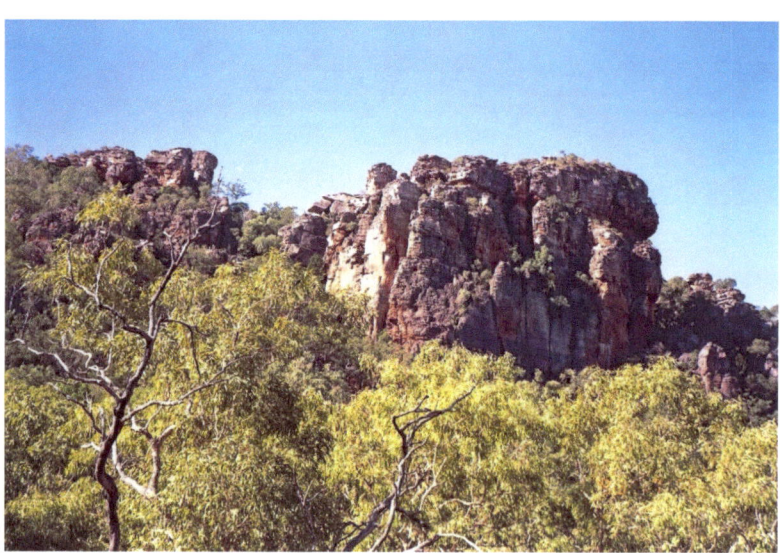

*Sheltered spaces in these outcrops protect the pictographs.*

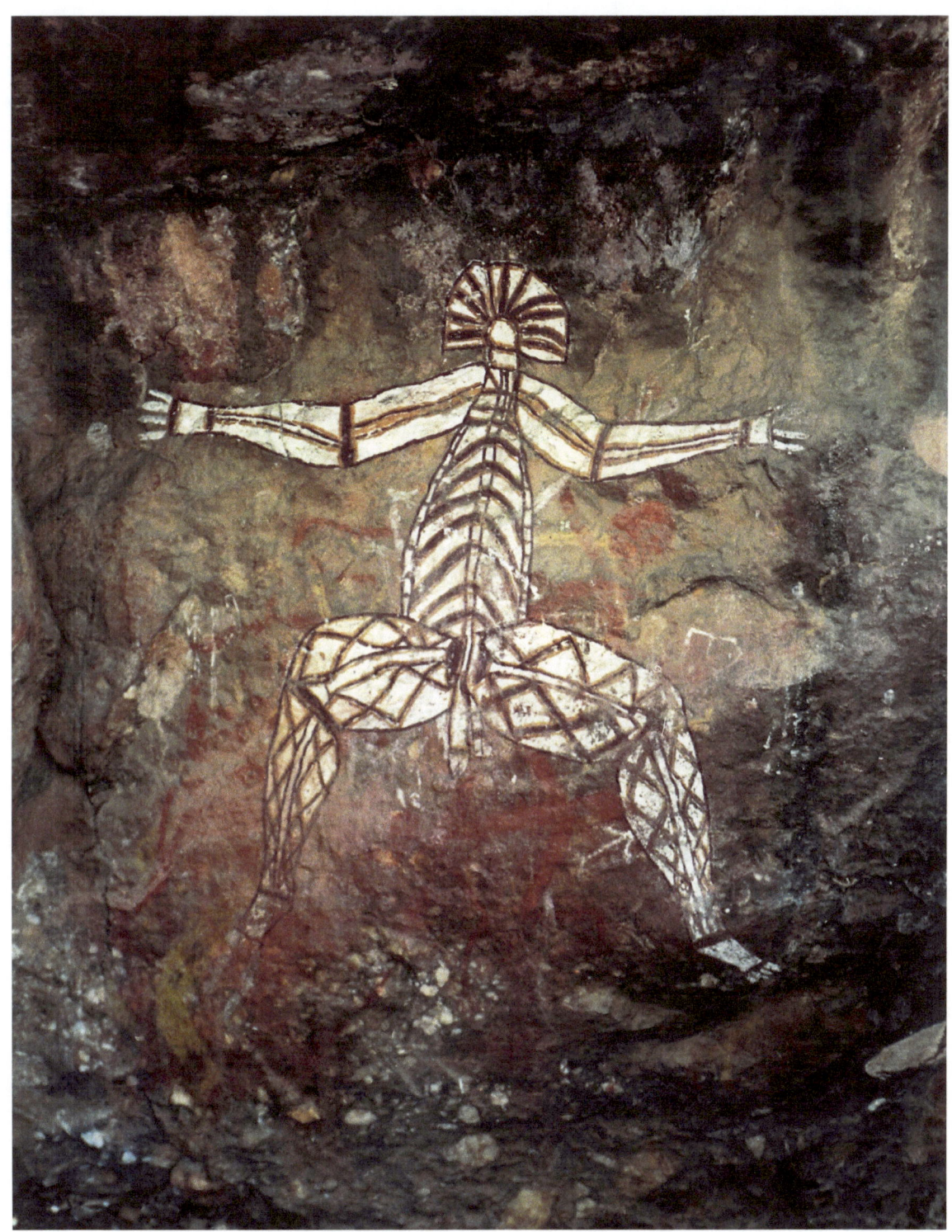
*Nabulwinjbulwinj kills and then eats women who disobey tribal laws.*

## Selected Bibliography

Chaloupka, G. 1993, *Journey in Time*, the world's longest continuing art tradition, Reed Books, Chatswood NSW, Australia.

Drew, J. 2004, *A Wardaman Creation Story by Bill Harney*, Australian Aboriginal Studies Press

Flood, J. 1990, *The Riches of Ancient Australia*, University of Queensland Press, St. Lucia, QLD, Australia

Lee, D. 2012, *Finding Yidumduma*, https://understandingdreamtimerockart.wordpress.com

*Park notes, Nanguluwur, Norlangie, Ubir*, 1993, Australian National Parks and Wildlife Service

Tanaka, J. 1993, On-site video recordings of Yidumduma's stories, unpublished.

Taylor, P. 2002, *Yubulyawan Dreaming Project*, ydproject.com

Trezise, P. 1993, *Dream Road*, a journey of discovery, Allen & Unwin Pty. Ltd., St. Leonards, NSW, Australia

Walsh, G. L. 1988, Australia's Greatest Rock Art, E. J. Brill–Robert Brown & Associates (Australia) Pty. Ltd., Bathurst, NSW, Australia

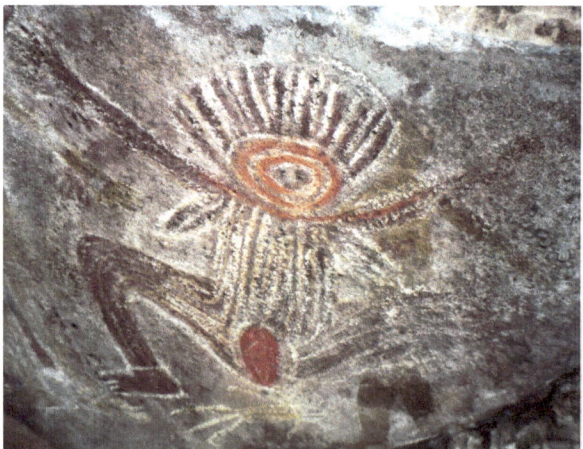

*"Wardaman Woman," Northern Territory.*

Photo credit: Erma Martin Yost, 1997.

## About the Photographer

Leon Yost is a professional photographer who has worked as a location scout for the BBC and is published in *Time-Life Books, American Photo, The New York Times* and many other publications. He has documented Native American rock art with his painter-wife Erma Martin Yost since 1976. In 1993 they toured northeastern Australia's outback, finding intriguing comparisons in the art of the ancient Aboriginals.

After 26 solo gallery exhibitions and two solo museum exhibitions–the Jersey City Museum in 1979 and the San Diego Museum of Man in 1997–Yost continues to seek out rock art sites wherever he can find them. You may contact him at ermaleon@gmail.com or follow him on facebook.com/leon.yost

Ed McCormack, of ARTspeak magazine writes, *"Yost brings an exquisitely refined pictorial sensibility to bear on the sacred sites he photographs, to imbue them with a haunting spiritual resonance."*

www.ingramcontent.com/pod-product-compliance
Lightning Source LLC
Chambersburg PA
CBHW051043180526
45172CB00002B/509